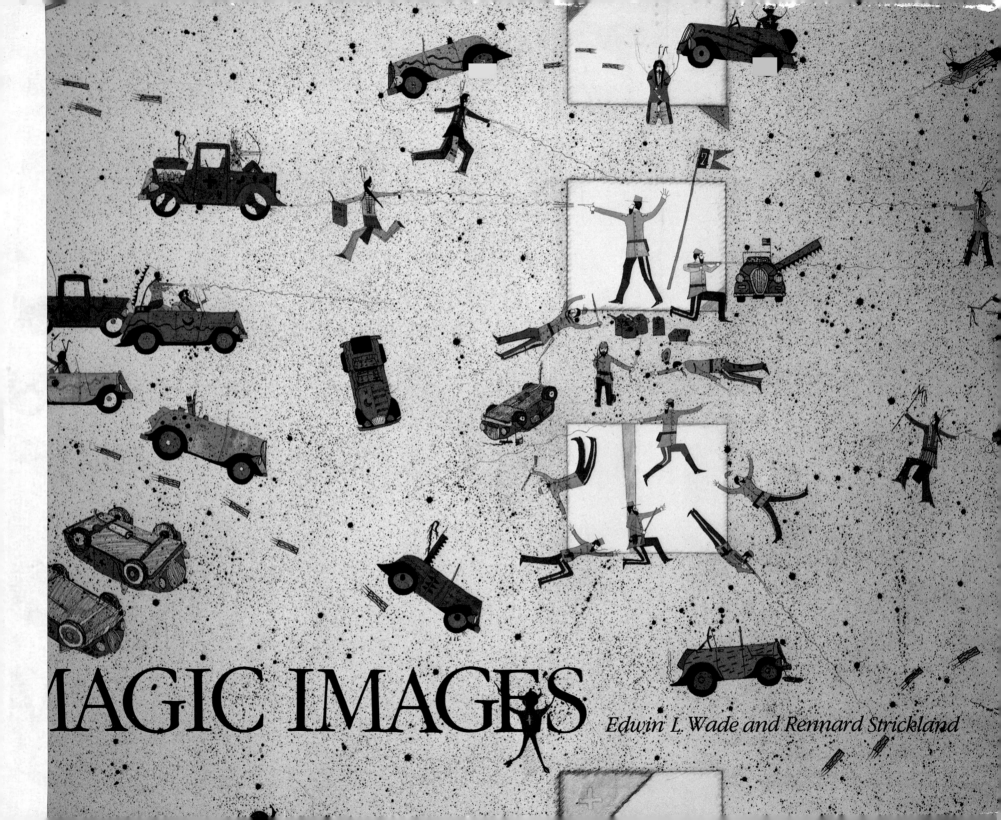

MAGIC IMAGES

Edwin L. Wade and Rennard Strickland

MAGIC IMAGES

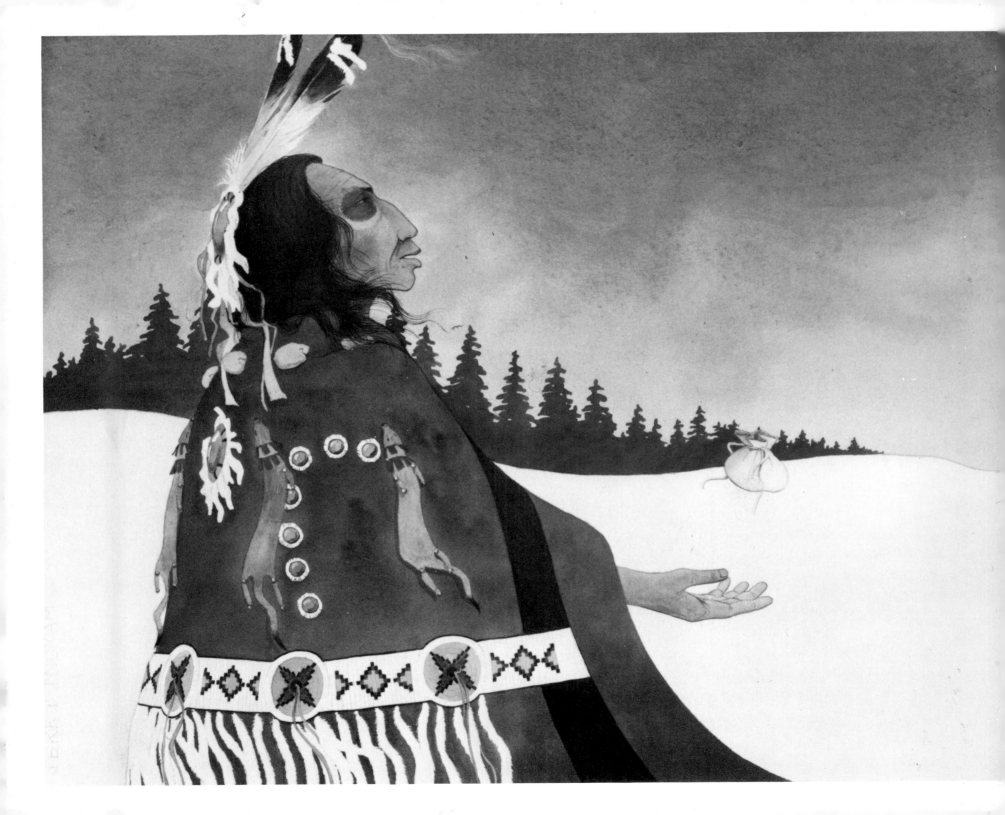

MAGIC IMAGES
Contemporary Native American Art

Edwin L. Wade and Rennard Strickland

Philbrook Art Center and
University of Oklahoma Press, Norman

COVER:
Randy Lee White (b. 1951), Sioux, *Custer's Last Stand Revised,*
1980, mixed media, 72 x 96, Elaine Horwitch Galleries.

FRONTISPIECE:
Jerry Ingram (b. 1941), Choctaw, *Winter Medicine,* 1981,
watercolor, 10 x 13, Collection of Eugene B. Adkins.

Sources of quotations and biographical information
found in the section of this book entitled *Magic
Images: The Artists and Their Work* are given in the
notes beginning on page 120. Dimensions of all works
of art are listed in inches, height preceding width.

Royalties from the book *Magic Images: Contemporary
Native American Art* have been donated by the authors
to Philbrook Art Center for the purchase of
contemporary Indian painting and sculpture.

Magic Images was designed and edited by Carol
Haralson. Editorial assistance was provided by John
Drayton and production assistance by Karen Kingsley
Litchfield.

The exhibition upon which this book is based, *Native
American Arts '81,* was held at Philbrook Art Center,
Tulsa, Oklahoma from August 2 to September 6, 1981.
The exhibition was organized and designed by Dr.
Edwin L. Wade, Curator of Native American Art,
Philbrook. Assistance was provided by Charles Taylor,
Thomas Young, Carol Haralson, Karen Kingsley
Litchfield, Isabel McIntosh, and Christine Knop.

We wish to thank the artists, their galleries, agents, and
collectors for their cooperation in loaning works to the
exhibition. Owners and lenders of the artworks are
credited in a full catalogue of the exhibition appearing
on page 124.

*This project has been made possible in part through
financial assistance provided by the State Arts Council
of Oklahoma, Jim Thorpe Building, Room 640,
Oklahoma City, Oklahoma 73105. (405) 521-2931.*

It is the conflict between rigid discipline and the genius of the great artists which gives such dynamic power to the images.

—Bill Reid

Art is big and there's room for everybody. I used to argue the old argument about the traditional painters and the modern painters . . . I don't think that kind of debate makes any sense anymore. There's room for every kind of painter.

—T. C. Cannon

CONTENTS

ACKNOWLEDGEMENTS

Our greatest debt is to the Native American artists who accepted Philbrook Art Center's invitation to participate in the exhibition *Native American Arts '81* from which the book *Magic Images* emerged. While the lenders of painting and sculpture are acknowledged by name elsewhere, their willingness to share these treasures was essential to the production of our book. We would particularly like to thank Jack Gregory, Eugene B. Adkins, and Mrs. Elizabeth Butler for their generosity. Philbrook Art Center and its patrons generously supported the exhibition and this book as a part of our major commitment to Native American arts. The following members of the Philbrook staff worked closely with the authors: Jesse G. Wright. Jr., John A. Mahey, Christine Knop, Isabel McIntosh, Steve Domjanovich, Karen Kingsley Litchfield, and Janet Stratton. At the University of Tulsa we are indebted to J. Paschal Twyman, Frank K. Walwer, Bradley and Gwen Place, Robert Patterson, David Farmer, and Caroline Seydell. John Drayton of the University of Oklahoma Press was involved in this book from the earliest planning stages. For more than a year members of the Philbrook Indian Committee maintained interest in and support for the project. This group includes Garrick Bailey, Richard J. Bigda, Mrs. Swannie Zink Tarbell, Arthur Silberman, Mrs. Jack Walker, John R. Wilson, and Mrs. John S. Zink.

The book benefited from a critical reading at manuscript and proof stage by Nancy Haynes. Many of the ideas in the essay "Beyond the Ethnic Umbrella" were suggested by H. Wayne Morgan. We are appreciative of the many artists, patrons, and critics who have visited with us and shared their views on this exhibition and our analysis of contemporary Native American painting and sculpture. The citations and notes section reflect our debt to the published works of scholars and critics.

Finally, there are debts generally beyond a simple acknowledgement. Rosemarie Spaulding typed the manuscript innumerable times and Carol Haralson's editorial and creative talents are reflected on every page of this book.

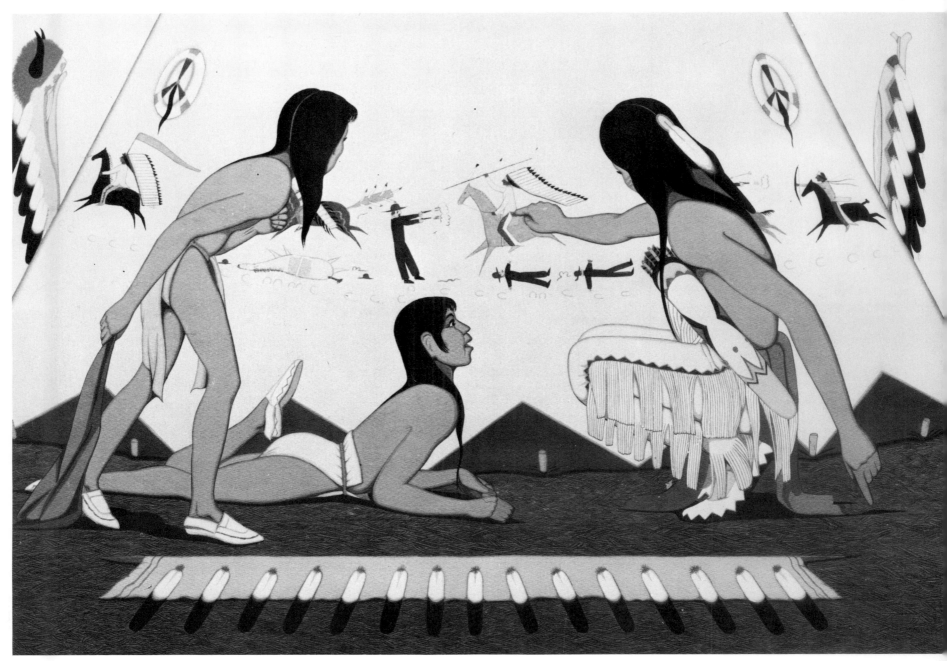

Oscar Howe, *Sioux Telling*

CONTEMPORARY INDIAN ART: EVOLVING IMAGES OF THE NATIVE AMERICAN

Edwin L. Wade and Rennard Strickland

Historic Native American art began as a rich and unique language in which intricately designed baskets, ceramics, painted skins, and sculpture replaced words. In the hands of a capable storyteller, magic images of unknown worlds sprang to life. But, as with the literature and visual arts of other cultures, Native American art has changed over time. Though its vitality and power remain, contemporary Indian art is vastly different from that created only ten to twenty years ago.

Within the last two decades Native American art has changed fundamentally. Art museums and galleries, which until recently shunned primitive art, proudly schedule Indian exhibitions. Investment speculation has driven Indian art into a multimillion-dollar industry. Northwest Coast masks and Pueblo ceramics, once considered ethnographic curios, grace the pages of national taste-setting magazines. Sensitive connoisseurs are eager to learn about the Native American, his value systems, and his artistic vision. The world of American Indian art is in flux. Old and new ways are colliding.

Magic Images: Contemporary Native American Art presents the visual statements of thirty-seven of North America's leading Native American painters and sculptors. These artists were selected as visual spokesmen for alternative definitions of American Indian art. No single style propels their work. They represent many trends, some bordering on emergent regional and thematic schools, that currently vie for the attention of talented native artists. While Indian art has never been a single stylistic world, today, more than ever, gifted young men and women are exploring divergent artistic avenues. For that reason we have selected art works that will represent the broad range of contemporary painting and sculpture. Regardless of differences in imagery, style, or technique, however, the works considered here were all created by Native Americans, drawing from Native American experiences and sensitivities.

Ideally, art criticism should not be encumbered by artificially defined categories, schools, or movements. We know it is too simple to suggest that all

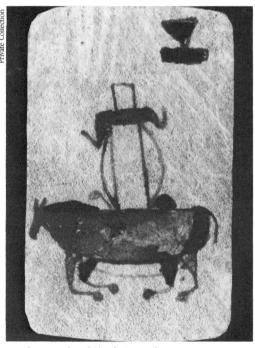

Apache painted rawhide playing card.

contemporary Indian painting and sculpture can be so divided, but for organizational and comparative purposes, some broad classification system is helpful. Native artists fluctuate between expressive avenues with increasing frequency. No longer is it possible to permanently link an Indian artist with a particular style. Therefore any meaningful classification system must apply to objects, not to artists. All works considered in these essays were classed as "historic expressionism," "traditionalism," "modernism," or "individualism." Works that do not fit easily into these categories were placed at the end of each section to provoke critical debate.

Historic expressionism, as a style, remains true to the techniques and design conventions of nineteenth-century tribal aesthetics, even though themes may have changed. As illustrated in the works of Bill Reid, Lyle Wilson, and Dempsey Bob, it is not a copyist or reproductionist approach. These artists pursue a valid personal reinterpretation of ancient conventions. For example, they employ the highly structured two-dimensional "form-line" design systems used by their Haida and Kwakiutl forefathers. By manipulating line and recombining iconography, they keep their works historically rooted and distinctively individual.

The *traditionalist* style retains a flat or two-dimensional shaded treatment of historic native imagery. It is represented in the works of internationally celebrated artists such as Gilbert Atencio, Andrew Tsinahjinnie, Archie Blackowl, and Harrison Begay. This is the style most often identified as "Indian" by the public, the style associated with the Santa Fe Studio of Dorothy Dunn and the "Kiowa movement," and the style encouraged in Philbrook Art Center's earlier annual competitions, held in Tulsa, Oklahoma beginning in 1946.

The *modernist* approach freely experiments with mainstream contemporary art techniques, yet retains visually identifiable Native American imagery. Thematically, it spans the entire expressive range of painting and sculpture, from realistic portraiture through bitter social commentary. Such distin-guished artists as Allan Houser, Dick West, and Millard Lomakema are unquestionably "modernists." Wintu artist Frank LaPena's *Deer Rattle – Deer Dancer,* in which ancient gods and spirits from California's tribal past are accentuated by modulated color and abstract balance, illustrates these conventions.

Individualism is not a single style but is totally indistinguishable from mainstream contemporary art. The artist's allegiance is to self, not to movements or ethnic identification. These artists are often mavericks, such as Richard Glazer Danay, Bob Haozous, and George Morrison, who exercise complete artistic freedom. They are frequently criticized for visually abandoning Indian tradition or subject matter and are challenged about their right to call themselves "Indian artists." Creek artist Phyllis Fife, for example, explores a highly personal, surrealistic journey through landscapes populated by ghosts and alter egos. James Havard teases the viewer with illusionistic, three-dimensional floating images.

The rapidly changing definition and uncertain expectations of contemporary American Indian art

Cecil Dick, *Deer Hunt.*

Philbrook

Ben Quintana, *Deer Dancers.*

Philbrook

Oscar Howe, *Dakota Duck Hunt.*

disturb many traditionally sensitive scholars and patrons, and some native artists. The worlds of Indian art are in collision; transition and accommodation will not be easy. Indian art no longer looks the same. It is no longer so soothing and reassuring. Contemporary Indian art disturbs and is intended to disturb. The flat, two-dimensional Julian Martinez *Deer Dancer* has been replaced by LaPena's less clearly representational deer figure. Oscar Howe's subtle and balanced *Dakota Duck Hunt* contrasts with Alvin Amason's *Papa's Duck* with its tin bucket and decoy attached to the canvas.

Many critics and collectors pessimistically announce the rapid decline and impending death of "authentic" native art. This suggests that the legitimate visual expression of Native American values, sensitivities, and aesthetics resides only in an older Indian art-producing generation, and that with its inevitable passing the process ends. Such premise, even though well-meaning, is patronizing and naive. It suggests that the vigor and talent so clearly evident in centuries of native art has suddenly run its course, that an aesthetic bankruptcy has occurred, sounding the death knell of America's once-great native artistic heritage.

In truth, Indian art is very much alive. Talent remains; the vision has changed. The new Indian art has adapted to new stresses, demands, and freedoms. The world of the contemporary Indian is fundamentally different from that of the Santa Fe and Taos art colonies of the 1920s and 1930s which nourished the incipient commercial Indian arts. As nineteenth-century tanned skins and ground ochres gave way to twentieth-century paper and watercolors, so today's artists employ canvas, panels, oils, tin buckets, and subway tokens. More important, they portray experiences at hand. It is not surprising that the contemporary Indian paints the world of the contemporary Indian and in so doing uses artifacts from the surrounding world. Change is not necessarily decline. Rather, it may be a natural process of growth, in this case an historic evolution consistent with the evolving world of the American Indian. The Indian artist who moves into a white mainstream may be stepping into an environment which many view as culturally and artistically stagnant. However, this is the world, polluted or not, which the artist and his tribe inhabit.

The conventional themes of Indian painting — richly costumed ceremonials, frantic bison hunts, brightly attired fancy dancers — have faded before new images of social commentary, personal inspiration, and abstract experimentation. It is not logical to demand that contemporary artists depict an ancient life they never lived. Indeed, to do so may not perpetuate Indian art, but may only encourage the mass production of caricature and historic illustration devoid of personal commitment, strength, and understanding. Great art is emotive. By the late 1960s what little emotion remained in much of Indian painting was being supplanted by a hollow commercial tradition devoid of feeling or content.

Dorothy Dunn's Santa Fe and Oscar Jacobson's Oklahoma are gone. Although the design schools they fostered were vital landmarks in the evolution of native art, those schools have been radically

Pablita Velarde, *Keres Corn Dance.*

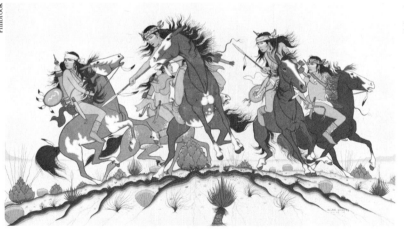

Allan Houser, *Apache War Party.*

Otis Polelonema, *Zuni Bean Dance.*

altered. The shift toward traditional techniques of the 1920s and 1930s was in many ways more abrupt than the changes we are now witnessing. The genuises of those early movements, artists like Fred Kabotie, Stephen Mopope, Monroe Tsatoke, Otis Polelonema, and Ma-Pe-Wi, created a rich legacy. However, it is inappropriate to canonize this heritage as the only legitimate Indian art experience. Indian culture is historically dynamic. For twenty thousand years, the influx of new peoples, materials, and inspirational events has infused a diversity into native arts, and the process goes on today. Early traditionalist painters expressed their era and their personal sensibilities as individual Native Americans. The contemporary compositions of Bob Haozous, Richard Danay, Allen Sapp, and Grey Cohoe express different aspects of an equally personal Native American experience.

And herein lies our ultimate inability to define a legitimate Indian art style. Non-Indians find it difficult to perceive the unique experience from which the Indian draws inspiration. Although museum curators, gallery directors, art historians, and anthropologists can familiarize themselves with the material and cultural manifestations of Native American consciousness, few can internalize basic native attitudes. The quality of being Indian, whether Winnebago, Kickapoo, Cherokee, Creek, Seminole, Haida, Hopi, or Hupa, is distinctive. It entails a distinctive orientation toward the world. Being Indian means having been taught personal values, aspirations, and rules of conduct different from many of those known to Anglo society. And these particular philosophies, whether the Hopi ideal of the unassuming, egalitarian good man, the Haida's pride and dedication to maintaining the dignity of his lineage, or the Chiricahua Apache's self-assertiveness, affect the way the Indian perceives the world and man's proper place within it.

Non-Indians often believe that there is a single state or attitude of Indianness. They suppose that all Indian tribes and all Indian peoples have the same cultural and aesthetic viewpoint. Not so. What is real and natural to a desert-dwelling Pima may be strange and foreign to a forest-dwelling Shawnee. Even tribes with common ancestors, such as the Creek and Seminole, see the world from a changed and changing perspective. This great diversity in Indian lifeways is reflected in the great diversity of Indian art. There is no single valid Indian cultural tradition any more than there is a single valid non-Indian tradition. What is a valid Indian experience for a Sioux in Los Angeles may be unknown to an Osage in Grey Horse, a Chippewa in Minneapolis, a Navajo at Window Rock, or even a Sioux at Rosebud.

Great art has been likened to a window on the soul. The future of American Indian art lies not in restrictive thematic or stylistic images but in the individual visions of artists attuned to native values and sensitivities. Seen in this light, the abstract collage sculptures of Hopi artist Charles Loloma take on added meaning. They open a window through which we can glimpse, if only fleetingly, another's world. Functionally they are jewelry, the brilliant compositions of a gifted artist. Yet their inspiration springs directly from Hopi consciousness, which

Indian painting is as varied as Indian culture and cultural areas. Above is George Kishkoton's study for a mural at Bacone College, which reflects the nomadic life of the Plains tribes. At right (left to right) are representations of village life among the Southeastern Cherokees, ceremonial ways of the Southwest pueblos, and the daily life of the woodland Chippewas.

Alfred Johnson, *Chunke Yards*.

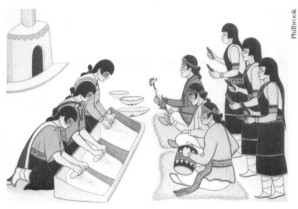

Al Momaday, *Corn Grinder*.

perceives them as philosophical sculptures rather than mere accoutrements or wearing apparel. When Loloma conceals complex mosaic designs inside a simple sandcast bracelet he is reaffirming the unassuming, unpretentious decorum of Hopi life. The great treasures of Hopi, enduring spiritual power and solidarity of family respect, are not materially visible but are secure within nondescript human vessels. Indeed, one could argue that Loloma's work portrays native concepts far better than the picturesque plaza dances painted by Awa-Tsireh and Julian Martinez of the early Santa Fe pictorial tradition.

While non-Indians may be unfamiliar with the full perceptual and evaluative framework of Indian culture, they can nonetheless appreciate the balanced, rhythmic motion in composition. Consider, for example, a nineteenth-century Acoma bird pot. The non-Indian does not share the aesthetic values of its Pueblo creator and does not evaluate the object's artistic merits by her standards. Yet the work of art speaks to both artist and viewer. The

non-Indian can appreciate how and why the artist creates and what creation means in the artist's world. And this shared understanding has the power to expand our Western definition of art and aesthetics.

Even the seemingly changeless world of the Pueblo potter is changed. The ancient potter would have rejected Western-inspired painting and paper as an unorthodox expression of design. She used pottery as her canvas. Yet old Acoma designs, once important as symbols of ethnic identification, have now been replaced by twentieth-century adaptations of prehistoric Mimbres figurative and black-on-white geometrics. The precarious balance between the vessel's form as sculpture and its function as a water jar has been virtually abandoned. Even so, the contemporary potter and her ancestor share a sense of self as part of an ancient living artistic community, continuous from grandmother to mother to daughter and on. In turn, they seek inspiration in the ancestral legends of their people, in analysis of the compositions of earlier potters, and

in the events of their own lives. Technically they are worlds apart, but culturally they are on a continuum. The next step is the evolution of the contemporary Pueblo easel painter, the Pueblo artist who transfers these ancient designs to canvas and reshapes them to fit a new media and perhaps to convey a new struggle.

Without an intimate, personal knowledge of Indian life and culture, who would presume to judge the appropriateness of change in the forms of Indian art? Artistic evolution, which is at the heart of any culture, is a peculiarly personal issue. Others not of the culture are, nonetheless, entitled to evaluate an art in terms of its aesthetic effectiveness, technical quality, and emotional depth. With Native American art, such critical considerations are appropriate because the larger world has become the audience towards which the works are directed. Using these standards it should be clear that the ancient artistic traditions of a changing people are still in capable hands, still producing the magic images which enrich the lives of all of us.

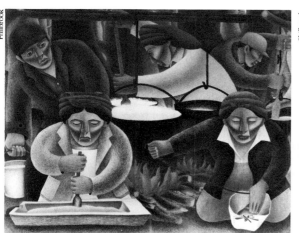

Patrick Desjarlait, *Maple Sugar Time.*

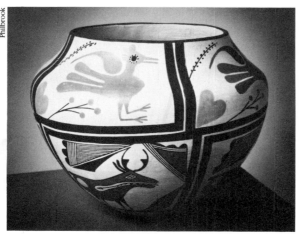

Rose Chino Garcia, *Acoma pot.*

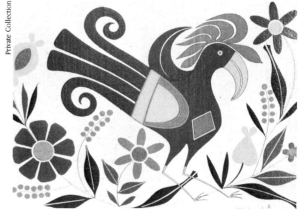

Helen Hardin's *Acoma Rooster in Garden* draws inspiration from traditional pottery designs.

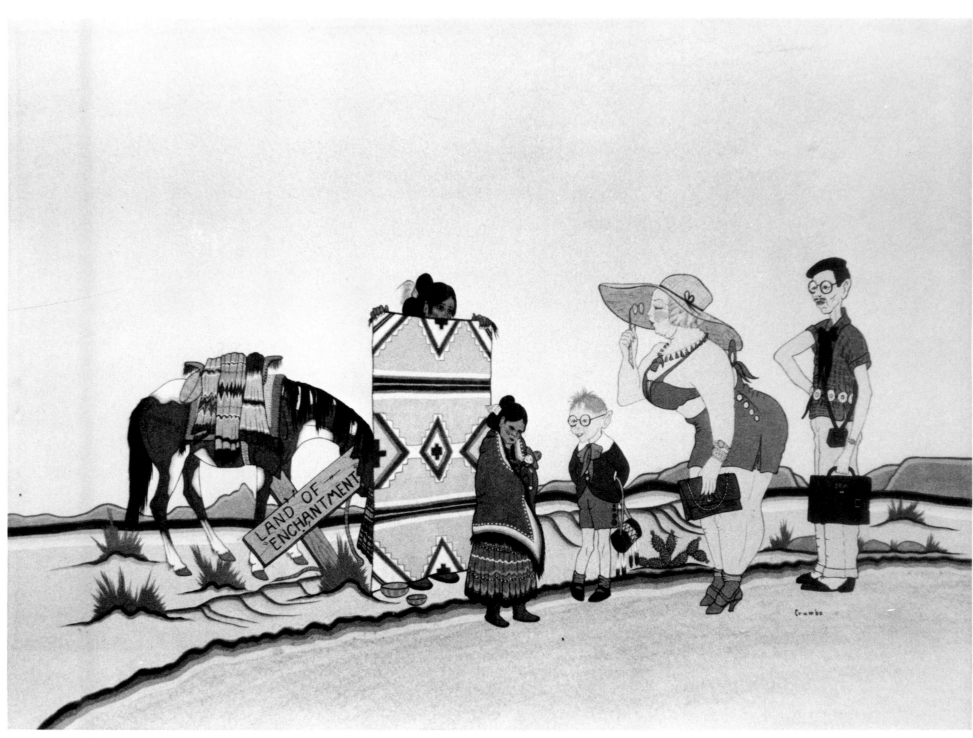

Woody Crumbo, *Land of Enchantment*.

THE ETHNIC ART MARKET AND THE DILEMMA OF INNOVATIVE INDIAN ARTISTS

Edwin L. Wade

Involvement in an ethnic art market poses an artistic and economic dilemma, an insidious double bind, for ethnic artists and their native communities. The market offers a source of fast income to communities that very often have less than substantial alternative sources of income. It encourages participation in a traditional field of activity, the production of arts and crafts, and provides the means by which communities can express their ethnic identity to a basically hostile industrialized world. At the same time these native communities are condoning the selling of their ethnicity in the form of stereotyped "exotic," "primitive" handicrafts. As a result, Anglo patrons come to identify a static commercial style as the "true" art of these peoples, rejecting the creations of more innovative artists.

Little attention has been directed towards the damaging effects of long-term participation in an ethnically defined art market. The demand for ethnic art is increasing, and large numbers of tribal peoples from South and North America, Mexico, Oceania, and Africa are responding. The initial economic and social inducements are great, yet neither the artists nor their western sponsors have considered the stifling effect of this restrictive production on a people's creativity. Artists who move away from tourist products to create art with a message, a theme, symbolism — art that is more socially meaningful — may find they have no place in the ethnically defined art market.

These problems now confront contemporary American Indian artists. The commercialization of indigenous arts has occurred for about 150 years, and it has been so intensive — in terms of numbers of people involved, amount of art produced and sold, and the many sophisticated ways in which the art and artists are promoted and publicized — that it serves as a classic case study of an ethnic art market. The market has now reached a point in its maturation at which the old relationships between artists, dealers, and patrons are breaking down and the philosophical and economic inconsistencies built into the system are being challenged.

Ethnicity, which enhances the salability of Indian art, restricts the themes, media, and techniques that artists can explore. A number of young American Indian artists are attempting to challenge these restrictions, to break with the current static perception of Indian art and to seek instead their own personal visions. The pattern by which they became victims of this system and the eventual resolution of the conflict should be recognized by all ethnic art producers.

During the past decade scholars have begun critically assessing tourist arts and ethnic art markets. But their books and articles have failed to impress the general public, and the scholarly community, with the social importance of these arts for the people who create them. Few realize that what began as a simple curio and knickknack trade has evolved into the main economic industry for many small-scale societies. A tourist art economy does not strip away their natural resources or dispossess them of their land; it encourages the retention of a semitraditional way of life. This has been true parti-

cularly for the Pueblo Indians of New Mexico and Arizona. In the 1920s craft production provided a necessary supplementary cash income to these societies, but by 1970 it had become the primary industry in over fifty percent of the pueblos. At Santo Domingo, for example, the marketing of crafts accounts for more than eighty percent of the pueblo's yearly income.[1] Continued stability and growth of the Indian art market has become critical to the financing of Indian lifeways.

The future of the native art market is uncertain. A "boom market" for ethnic art, stimulated by the speculator-investor, has caused a great market instability.[2] The transitory fad for Americana and our zealous searching for roots has created a great demand for this art. There is no assurance, however, that the lavish attention given the American Indian over the past ten years will not be turned off as fast as it was turned on.

The most serious threat to the Indian art market is persistent Anglo domination of Indian aesthetics and creativity. The market is built on a stereotyped,

purist vision of traditional Indian art and culture, a vision which has little tolerance for unplanned, potentially disruptive innovation. Whose right is it to say what is good art or bad art, what is traditional or avant-garde, what is Indian or non-Indian? For the past fifty years the course of Indian art has been determined by Anglo-conceived and -directed Indian art associations, historical and preservation societies, museum art revival programs, and federal arts and crafts projects. Their policies have been relatively easy to enforce. Through the selective allocation of federal craft money, with Anglo patrons, scholars, and dealers sitting on the various associations' art judging panels, and with non-Indians controlling over ninety percent of all wholesale and retail outlets for this art, it was a simple matter to reward what they liked and damn to obscurity what they did not.[3]

This is what a market is all about: the simple process of supply and demand. If a producer cannot make a product suitable to consumer taste, he must change his product or go out of business. In the

Indian art market, however, the general consuming public has never had a chance to see the full range of contemporary and innovative art.

Without question this is a problem for all artists, mainstream American and European as well as ethnic. As a consequence, there is little sympathy for the Indian artist who decries the degree of control the market exerts over the character of his art. But unlike mainstream artists and craftsmen, who choose their occupation over more conventional careers, the Indian does not really have much of a choice. Especially in the Southwest, Indians are programmed throughout their elementary and secondary educations to believe that arts and crafts production is their one claim to fame in the white world. The commercial arts are advanced as the Indians' fastest, surest, and most lucrative form of social mobility. In fact, the federally funded Institute of American Indian Art in Santa Fe, New Mexico, was founded on this premise. And the premise has been sound. It has proven absolutely true that with a moderate amount of talent an Indian artist can

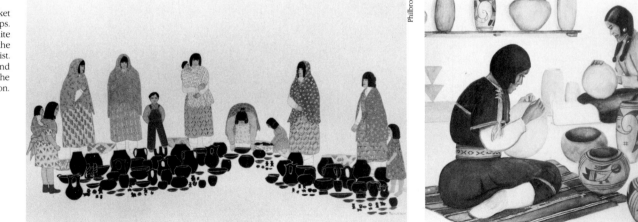

The evolving economy of the Indian art market radically altered Indian and Anglo relationships. Native artists now became producers for white tastes, and the pottery maker became the 20th-century stereotype of the Indian artist. Pablita Velarde's *Pottery Sellers* (left) and Douglas Shupela's *Pottery Makers* record the phenomenon.

make money, often a lot of money. Whether this will continue to be true remains to be seen.

In the marketplace, the problems confronting Indian artists cannot be equated with those of mainstream American artists. If the mainstream Anglo artist has difficulty selling his art and eventually fails, it is his own problem: he chose to gamble at a high-risk career and knew what he was getting into. The same argument is not true for the Indian artist. For him the choice is more cultural than personal. It is not easy for Indians to pursue most conventional careers. Until quite recently few saw the need for Indian lawyers, doctors, or engineers. Thus, many Indians turn to commercial arts and crafts simply to make a living, and they are faithful to the prescribed styles and media so as not to endanger that livelihood.

The intellectual justification for this system was the nineteenth-century philosophy whereby Anglos assumed the right and responsibility to direct the internal affairs — including the art traditions — of other cultures. By the 1880s official policy at Indian boarding schools was that traditional arts would be suppressed and utilitarian handicrafts encouraged.[4] Government-licensed Indian traders continued the practice and so sponsored small craft fairs and competitions for the natives with whom they dealt.

By the first years of the twentieth century traders and collectors were beginning to prize Indian art for more than its utilitarian value. In 1909 the superintendent of the Navajo Agency at Shiprock, New Mexico, instituted an annual fair to encourage the production of higher quality Navajo arts and crafts. Competitions were held at these fairs, and prize money was awarded for outstanding pieces. These prizes were furnished both by the agency and by local traders who were invited to attend the events. During that first year there were 230 native wool blankets on exhibit with a colorful added attraction of twenty-five Germantown textiles. By the fourth annual Shiprock fair the number of blankets for sale had increased fourfold, and the quality of the pieces had also risen.

These fairs came to be economically important to the Navajos because traders and an increasing number of collectors were present to compete for the products. Craftsmen began to depend on extra money from the sale of their art. The amounts paid were generally small, at best a dollar or two, but the Navajos were poor and the added income was welcome.

The intent of the United States Indian Service in sponsoring fairs such as the one held in Shiprock was to benefit the Indian. And in fact the Indians did benefit. Traders of course also benefitted by having an increasingly wide variety of arts and crafts from which to choose. Together, the federal Indian Service and the traders began laying the ground rules for controlling the quality and even changing the styles and designs of native art traditions. Their intentions were to a great extent altruistic, especially during the opening years of this century. However, an old pattern was repeating itself: Anglos looking out for the welfare of the Indian were opening the way for greater control of an Indian market

Private Collection

Grey Cohoe's *All Day Saturday at the Store,* an intaglio print, uses a recurrent image from the past one hundred years of Navajo life.

centralized in the hands of white administrators. Certain traders began to use this relationship to induce Indian craftsmen to abandon entire art traditions and cheapen and downgrade others.[5]

The Indian Service was not the only organization involved in the staging of arts and crafts fairs. Several other groups, mainly philanthropists, were active in promoting Indian art and supporting various fairs and competitions. Organizations like the Southwestern Association on Indian Affairs, the Museum of Northern Arizona, and the Eastern Association on Indian Affairs stated that their sponsorship of such events was for the betterment of the Indian people. The main audience, however, was the Anglo tourist who came to watch and buy curiosities.

The ultimate objective of these philanthropic groups was to convey the value of the American Indian heritage. And so began the song, dance, and native costume extravaganzas. At the Santa Fe Indian Market tourists were enchanted by the sounds of tortoise-shell clappers, the rhythmic pounding of moccasined feet on the grassy downtown plaza, the Navajo women in their embroidered shawls and turquoise beads, and the velvet shirts and concho belts of the Navajo men. As early as the 1920s, a hundred thousand tourists rushed to Santa Fe's Indian market and fiesta each summer convinced that the Southwest Indian way of life was worthy of the highest praise, and most of all that it was worth being preserved.[6]

The philanthropist, or humanist, used the Indian, paraded him around in native costume, asked him to dance for Anglo tourists, even changed the form and content of his arts and crafts. In this the humanist differed not at all from the trader. The real difference was motive. To the humanist the preservation of Indian culture was of first importance. The arts and crafts were inseparable from the culture; therefore, if the art were permitted to die — or, worse yet, grow into some new commercial style — part of the culture would die also. The trader was not so concerned about the changing nature of Indian societies. His reason for promoting the arts was to create a product popular enough to provide a relatively stable economic base for the reservations. More money for the Indian meant more money for the trader. The trader fully accepted the fact that to be a commercial success artists might have to discard traditional, often time-consuming techniques, such as the use of vegetable dyes in textiles, or replace ancestral designs and compositions with ones that held more meaning for the Anglo buyer.

The humanist organizations built into their craft-revival programs a mechanism that guaranteed them a fairly high success rate. Initially a scholar in the group, or a venerated patron with a reputation as an intellectual and ardent supporter of the arts, proposed an innovative style or technique. He "blueprinted" the desired style and then, as an architect hands over his plans to the construction crew, delivered these instructions to the Indian artist. The involvement of the scholar in these programs was crucial, since he gave credibility to the new art form. His years of training and vast know-

At left are Native American participants in Philbrook's 1958 annual exhibition of Indian art. At right, attired in a composite Plains and Prairie costume, Acee Blue Eagle teaches the mysteries of Indian picture writing.

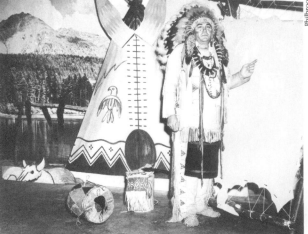

ledge were assumed to qualify him to map out a revival as traditional as if a native of the culture had invented it. These newly contrived Anglo arts were passed off as a direct link in an unbroken chain of the purest Indian tradition. The contention was that even a lost art form was not forgotten. The humanist, many believed, was able to jog the Indian's subconscious racial memory and cause him to remember where his ancestors left off. Thoughts like this brought the Santa Fe Studio of Indian painting into being. An influential Indian art patron, the president of the Southwest Association on Indian Affairs in the late 1930s, proudly acknowledged Anglo control over student work at the Santa Fe Studio:

Ninety percent of the young Indians have to be trained away from the white man's influence, according to Miss Dunn, before memory awakens in them the vast store of their art tradition. Students engage in a long performance of experimenting with tricks of naturalism such as light and shade and perspective and attempts at anatomical drawing before they realize that those things have nothing to do with the fundamental qualities of Indian art which is in itself simple and undeceptive, quite unnaturalistic.[7]

The legitimacy of studio school painting as a traditional Indian art form (or an extension thereof) is currently a very sensitive subject in the Indian art market. Many studio advocates continue in the face of all contradictory evidence to defend the studio as a reviver of lost art. However, it is impossible to ignore that students were not given the freedom to decide what they wanted out of their art. Well-meaning instructors compiled a collage of prehistoric Pueblo motifs and, for the Navajo and other nomadic tribes, an assemblage of romantic images such as barren buttes, windswept weeds, plateau lands, sheep grazing at sunset, defiant steeds, and homey Indians. The studio's policy was one more example of the white man's knowing what is best for the Indian.

One very dangerous precedent these humanists set was to advance their goals through a system vulnerable to conflicts of interest. Conceiving a new art form, getting the Indians to produce it, and then purchasing the finished product was fine. In one sense this is what the term *patron* is all about. But when the patron and his friends elected themselves to the judging panels of arts and crafts exhibitions, the conflict began. There was no way the patron could be an impartial judge. His awards would go to Indian artists turning out the art he had encouraged. This might have been beneficial for the select few who took part in the patron's pet project, but the others found only rejection. A few years without ribbons convinced the losers that their sole recourse was to sign up for the same arts and crafts project and learn the new style.

Although forty years have elapsed since these new programs began, the situation has changed little. As the painter Fritz Scholder observed about current supporters of Indian art judging competitions:

The traditional commercial image of Native American femininity has been replaced by the realism of our fast but insecure lives. Compare Theodore Suina's *Navajo Shepherdess* (left) with Bob Haozous's *Sensuous Cowgirl*.

The so-called patrons of Indian art are still very closeknit and often ingrown. Any outside patronage threatens many of the traders, museum people, professional Indian lovers, experts, and yearners. One must also realize that too many organizations that profess a desire to benefit the arts are actually interested mostly in benefiting themselves. The artist is often used as a pawn for power plays and social happenings.[8]

Artists especially began to feel like "pawns" when one year they won several awards and the next year were completely ignored. Or they might enter at Indian Market and win, and yet find their work not accepted at other shows. Certain competitions were noted for bias toward the traditional. Many of these flatly rejected anything that did not fit their definition of "real" Indian art. For example, when one judge presided at a competition, ceramic plates were never given awards because, in that person's opinion, ceramic plates were nothing but a commercial art form. In 1974, Indian art magazines, collectors, and dealers were praising potters for their innovative use of turquoise, shell, and precious metals to accent the design and shapes of their ceramic creations. Yet in that same year a judge at the Gallup Ceremonial flatly stated that turquoise should never be incorporated into pottery, that any pot with turquoise accents should be automatically disqualified.

Artists like Oscar Howe, Dick West, Joan Hill, Fritz Scholder, R. C. Gorman, Robert Penn, Harold Littlebird, Bob Haozous, and Dommick LaDucer have all encountered protests against their work because it was too different and not Indian enough. Experimental artists often have to wait a long time to be appreciated by Indian art collectors and dealers. Bob Haozous commented on the problem he has faced as an innovative sculptor:

The objections have come from the people who make money off Indian art. They're afraid that what they have will be threatened if something new comes in. The buyers are used to buying traditional items and the Indians are used to making them. If you come up with something different, it's too threatening. It's like coming up with an automobile tire that isn't made out of rubber. All the big tire companies would outlaw it. . . .

The kinds of innovators that are promoted . . . are innovators who take slow steps. They paint an off-white sunset instead of an orange one. The Indian art that is really innovative doesn't take slow steps, and consequently that type of art doesn't sell.[9]

The serious gap between the professed intent and the actual outcome of these exhibitions has sparked hostile protest by a number of Indian groups and individual artists and craftsmen. The American Indian Movement (AIM), Indians Against Exploitation, several Navajo National chapters, and the Coalition for Navajo Liberation have objected violently to the manner in which many of these exhibitions are conducted. The Gallup Ceremonial has provoked the most criticism, for what Indians

Oscar Howe's use of abstraction and cubism challenged the stereotypes of Indian painting in the 1950s with such works as *Dance of the Heyoka.* Paintings such as Fred Kabotie's *Hopi Ceremonial Dance* (right) came to symbolize Native American painting.

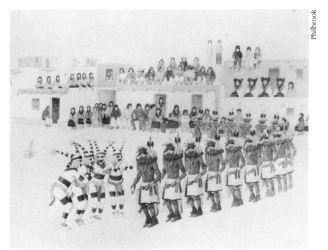

perceive to be its racist and exploitative nature.[10] Many feel Indians are encouraged to perpetuate a false Hollywood image of their traditional life. They are also asked to perform private ceremonies publicly. Indians are strongly urged to come in costume, to march in the parade so that their exotic dress can be viewed by the tourists, and to demonstrate their native dances, arts, and rituals. Foot races, bareback-riding contests, and chicken pulls have enhanced the carnival atmosphere of past ceremonials. They have also drawn large crowds who spend money at Gallup's motels and restaurants. Further, Anglo dealers who attend the Ceremonial to sell Indian arts and crafts benefit as well from the costume parades and dance performances. The crowds come to see the Indian spectacular, and they buy reminders of what they have seen.

It has occurred to many Indians that they are putting out much effort at these exhibitions for very little return. In fact, sentiment against the Gallup Ceremonial was so strong that in 1973 a petition was circulated by Indians Against Exploitation to have New Mexico state funds withdrawn from the Ceremonial. The petition was signed by 1,200.[11] The Gallup Inter-Tribal Indian Ceremonial boasts that it is "the nation's outstanding living memorial to the American Indian and his civilization." Its stated purpose is to stimulate "an appreciation of high quality Indian arts and crafts among both Indians and whites" and to "provide a meeting place for a broad cross-section of Indian tribes to gather, barter, and compare the skill of their crafts and the form of their dances."[12] Many Indians feel, however, that only Anglo dealers and the city of Gallup benefit. The Ceremonial is seen as a costume ball for which the Indians pick up the tab.

Organizations that sponsor arts and crafts exhibitions have become sensitive to complaints of Indian artists. The practice of placing Indian artists on judging panels has increased as a means of counteracting such complaints and preventing the problem of Anglo bias. But this has not always worked out well. Indian artists, like Anglo art collectors or dealers, have a vested interest in the Indian art market.

It is the artist who is affected first by any new trends that may be established through the judging process. If experimental, nontraditional art wins most prizes, the market for traditional pieces is hurt; the same is true if the process is reversed. Overrepresentation of Indian artists on a judging panel can create as much dissension among those being judged as an overrepresentation of Anglo dealers, collectors, or scholars. Thus, when the Heard Museum selected a panel consisting solely of Indian artists for their 1973 Annual All-Indian Arts and Crafts Exhibition, a local Phoenix news reporter wrote: "And the show which opens Friday promises to be the most controversial one in the history of major exhibitions. All thanks to that all-Indian jury."[13]

Precipitating the controversy was the Heard's awarding of First Place in Sculpture and Best in Show to Dommick LaDucer's *Horse of a Different Color,* an impressionistic wood sculpture of a horse, collapsed and exhausted, struggling to get up. To communicate the horse's frenzied determi-

A comparison of Dick West's *Water Serpent* (right) with Pablito Velarde's *Battle of the Serpents* (left) shows the bankruptcy of the conflict over traditionalism versus modernism. Critics labeled West's painting as modern and Velarde's as traditional.

nation to stand, LaDucer used rough angular lines; this, and the fact that the carving was not complete, suggested that the horse's struggle was not over. Awarding top prizes to this work was controversial only because it occurred at an Indian art competition. No visual distinguishing attribute or style identified the work as that of an Indian. This was the basic issue. *Horse of a Different Color* could have been created by a white artist. To award it top prize was to challenge the traditional perception of Indian art.

What is legitimate Indian art? The question dominated the Heard exhibition. It soon became clear that the judges were polarized in their opinions on the issue. Although the judges of this competition were all innovative, progressive Indian artists, two of them — Helen Hardin and Joseph Lonewolf — claim that their work is closely tied to their cultural heritage, and that they are sympathetic toward a "traditionalist" approach. Two other judges — Bob Haozous and Fritz Scholder — feel that to be forced to pursue a "traditionalist"

approach is too restrictive and that traditionalism is not the only acceptable form of Indian art. Clearly, neither side wanted to surrender. Although LaDucer's piece won two top awards, the "traditionalist" faction made their concession grudgingly. Joseph Lonewolf commented at the close of the exhibition, "I make no secret that I am disgusted and discouraged with some of the judging of this show."[14]

It is fortunate for Dommick LaDucer that this controversy occurred at the Heard Museum show, where the only judging categories for sculpture were stone, metal, and wood, and there were no restrictions excluding a nontraditional piece like *Horse of a Different Color*. In some juried exhibitions a nontraditional piece may be overlooked because it finds no convenient category, or it may be buried in the list of "miscellaneous" entries. Such restrictive and often outdated judging categories are a serious problem.

Regardless of the controversy, ethnicity remains the key selling point on the Indian art market. Indian artists are asked to act in accordance

with what Anglo patrons think of as Indian consciousness — to wear exotic clothes and jewelry and to maintain that their art springs from the spiritual oneness they have with their people and religion.

So what is contemporary Indian art? One outspoken Indian, a critic on the topic, feels that

Indian art is a bundle of safe, decorative ideas and motifs that have been repeated so doggedly they have lost all ability to communicate or awaken our aesthetic senses. It's become a prop for the interior decorator. It is a safe niche. It is a place where Indians can hide when they do not want to compete with the great artists of the non-Indian world.

I've lived in many different situations, with Indian families, my own included; with white people; in the city and in the country. I've related to all different kinds of peoples in different settings. With this background have come a lot of different feelings and experiences. So I don't see why I only have to do Indian art. Yet

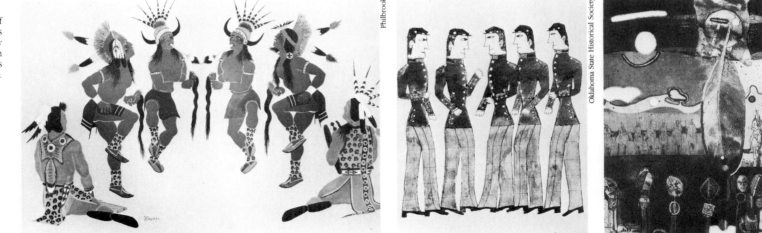

The Oklahoma Plains style of Stephen Mopope's work was viewed by some as the only acceptable style of Indian painting. At left is Mopope's *Kiowa Scalp Dance*.

Philbrook

Oklahoma State Historical Society

Private Collection

that's where the paradox comes in; I'm still doing Indian art.[15]

Is "Indian art," then, a racist term? Is the Indian artist required to stay at the back of the museum throughout his career? We should have learned three decades ago that "separate but equal" does not work.

Most Indian artists are deeply concerned about the future of their art. Regardless of how commercialized it may have become or how much it has changed from the traditional, native art is still a source of pride for its makers.

The arts have become the testimonial to Indian people that their culture survives. The artists have demonstrated their special talent for creating a rare and highly desirable commodity. The increasing demand for native arts attests to that. The involvement of tribal societies in a commercial arts and crafts market has resulted in drastic, lasting changes in the individuals and their communities. Despite these changes, Indian societies have made it to the close of the twentieth century. Without the desper-

Tom Boylan
3rd Grade
Miss Lytle
Room 103

My favorite Hobby

Sept 22 1976

My favorite hobby is Indians. I like to read about them very much. I collect books about them and also plastic ones that I play with. Last summer my parents took me to where they live. It's called a reserevation. We saw many Indians there. They danced and sang songs My mom bought me a painting from a real Indian for thirteen dollars. It is haning in my room. Indians are a fun hobby.

ately needed cash income the arts and crafts provided, many of these cultures might have dissolved in the melting pot of America. The Indian art market was a bulwark that staved off poverty and cultural dissolution. This market continues to be too important to risk losing. At stake in years to come is not merely a steady income but also a way of life. Money from arts and crafts enables the Indian to remain in his home community and to take part in his traditional ceremonies. If the income is lost, this way of life will no longer exist. It will be remembered only as a romantic passage in the history of America.

Native American art has always explored the unique and unusual, whether that be the white soldiers depicted in an untitled painting by Buzzard in 1870 (opposite center), or the polemical imagery of our 20th-century artists, as expressed by Grey Cohoe in the recent intaglio *Morning Indians #1* (immediate left).

Indians Are My Favorite Hobby (above) is a recent painting by Richard Glazer Danay. This work, painted in oil on canvas, was taken from an actual letter.

MAGIC
IMAGES

THE ARTISTS AND THEIR WORK

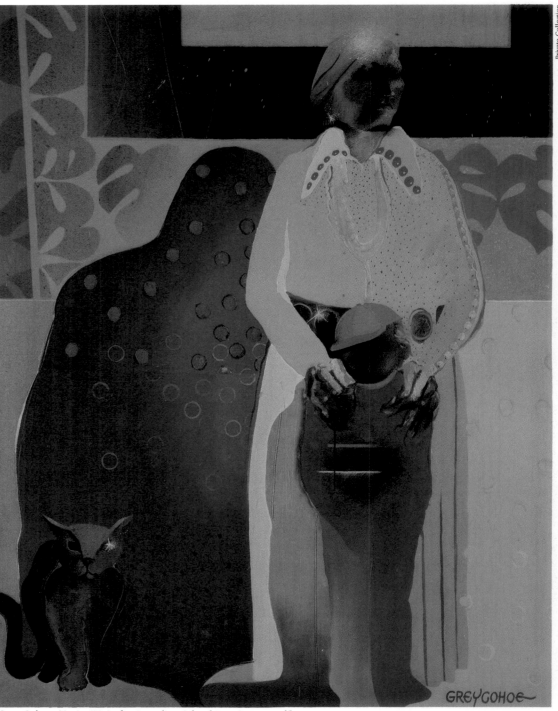

18

Grey Cohoe, *Tocito Waits for Boarding School Bus*. See page 65.

George Morrison, *Landscape*. See page 86.

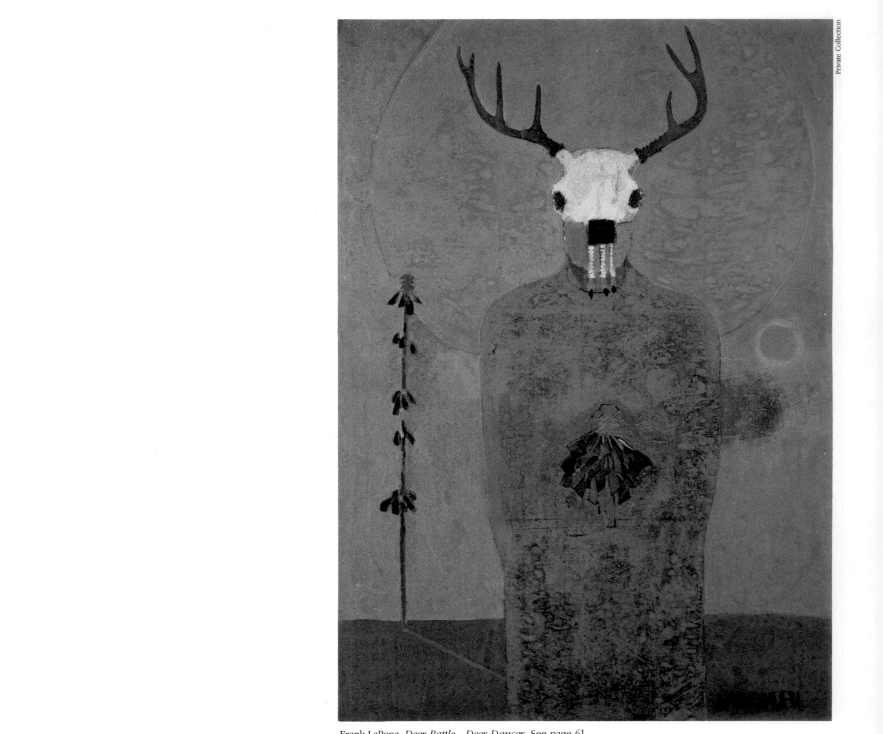

Frank LaPena, *Deer Rattle—Deer Dancer*. See page 61.

Phyllis Fife, *The Poet in Painter's Clothing.* See page 87.

21

George Longfish, *You Can't Roller Skate in a Buffalo Herd Even If You Have All the Medicine.* See page 79.

Richard Glazer Danay, *I'll Take Manhattan* (front view). See page 96.

24

Dan Namingha, *Mesa*. See page 88.

James Havard, *Eagle Egg.* See page 76.

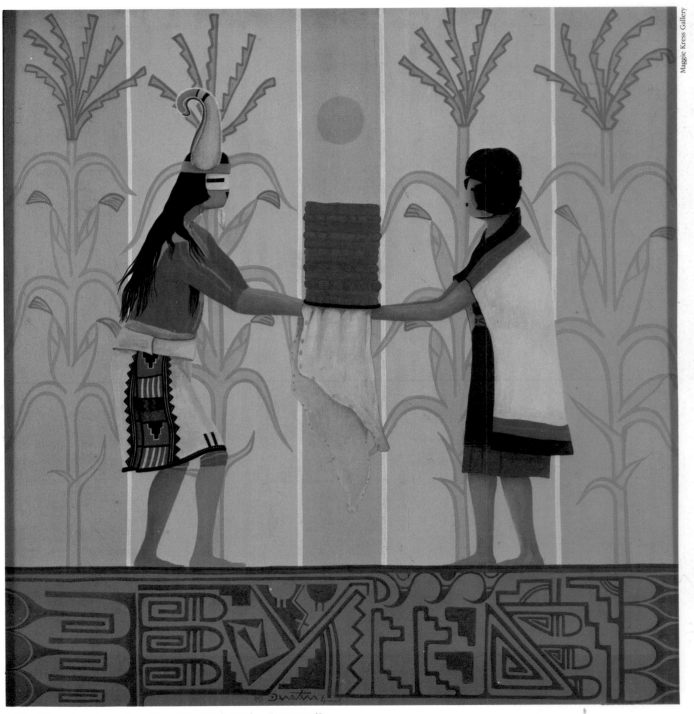

26 Millard Dawa Lomakema, *Two Horn Priest with Maiden*. See page 43.

Andrew Tsinahjinnie, *Pastoral Scene*. See page 44.

Randy Lee White. *Custer's Last Stand Revised*. See page 36.

HISTORIC EXPRESSIONISM

HISTORIC EXPRESSIONISM *is a style that re-*
mains true to the techniques and design conven-
tions of nineteenth-century tribal art. Themes may
change, but these works remain historically rooted.
At the same time, they are distinctly individual. A
personal use of image and line marks each artist's
work as his own. The artists who work in the style of
historic expressionism are not copyists or reproduc-
tionists; they are reinterpreters of an ancient tradi-
tion.

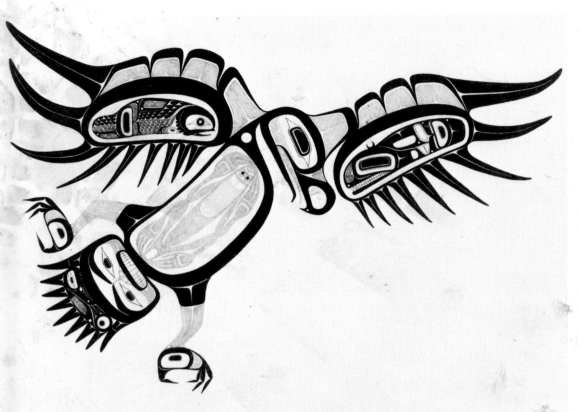

LYLE WILSON, b. 1955
Haisla/Kwakiutl

Crest Memorial of the Haisla, 1980 Pencil, 15½ x 22¼	*The Shaman Restores a Dead Soul to Life,* 1980 Pencil, 14 x 19½

Lyle Wilson clothes ancient Northwest themes in innovative forms to present contemporary themes. Critics have noted that his work develops modern concepts within a style which is at once Northwest Coast and highly personal. Wilson's carving was influenced by that of his uncle, Sam Robinson, and by his extensive university study of graphic design and etching, lithography, and engraving. In explaining the evolution of the technique used in *Crest Memorial of the Haisla,* Wilson notes, "The multi-shade pencil drawing is essentially a new medium for the presentation of Northwest Coast Indian themes. The impression and depth provided in this medium produces effects not possible with normal solid two-color design. Note that no straight edges were used." The work itself incorporates the major clans of Kitimaat (People of the Snow). Included are the Beaver, Fish, Blackfish, and Raven clans as reflected in Wilson's own crest, the Eagle.[2]

The Shaman Restores a Dead Soul to Life is a handsome example of Wilson's use of elements of the old art, particularly in the wedding of story and design. He has reinterpreted an ancient carved wooden grave box as a symbol for the transformation and ultimate resurrection of life. In this powerful image, as in many old "symmetrical" designs, there are subtle and intriguing differences between details of the left and right sides. But what we see here is more than a tinkering with old design rules. It is a refinement in which old legends and crest figures break free of their ancient context.[2]

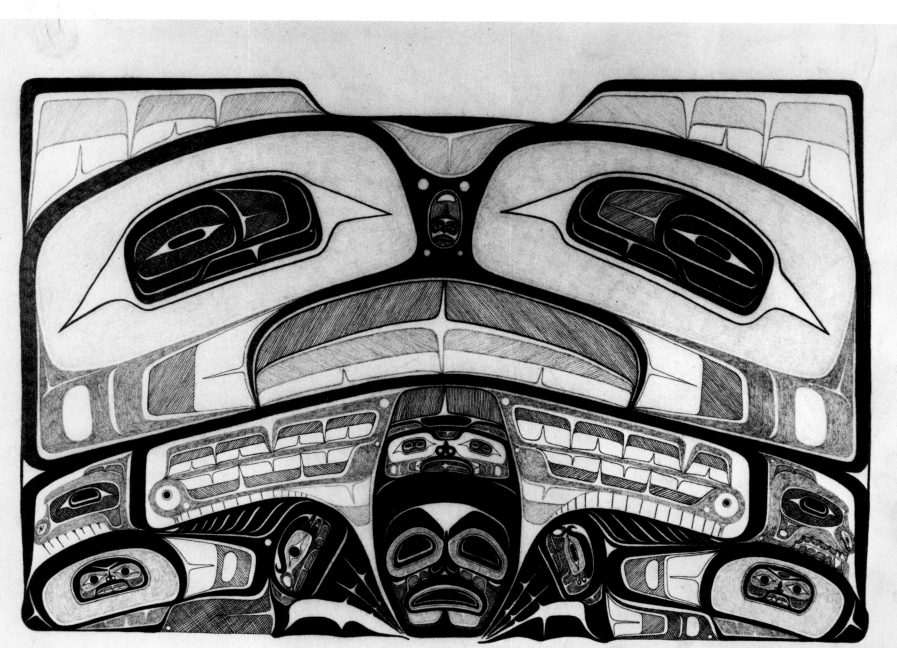

Departure Piece #2 "The Shaman Restores a Dead Soul to Life" 6/13/80

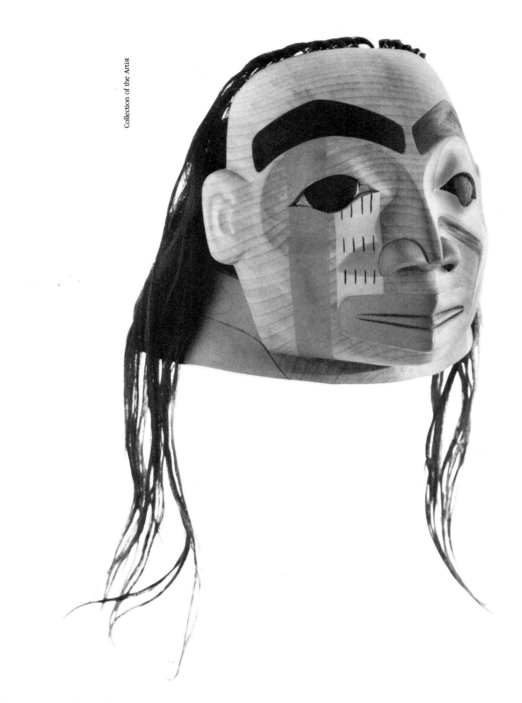

DEMPSEY BOB, b. 1948
Tlingit/Tahltan

Eagle Warrior	*Old Woman Face*
Helmet, 1981	*Mask,* 1974
Alder wood, hair,	Alder wood, copper,
8 x 12 x 9½	horse hair, hair,
	9 x 7 x 4

"You cannot separate the art from the people," says Dempsey Bob. In Indian life, particularly the traditional life of the Northwest Coast, art was not something set aside; like fishing, it was part of the whole fabric of life. As one of those who have returned to the ancient art of carving, Dempsey Bob acknowledges a great responsibility to his people. He uses the old designs, drawing upon forms his people once gave to blankets, drums, rattles, and masks. He is determined to lead his people as his war leader and artist ancestors have done for centuries.

Eagle Warrior Helmet is an example of mature Northwest Coast art in both medium and motif. Though rooted in ancient style, it is still highly individual. Lacking an apprenticeship wherein to learn from the tribal masters, Bob has taken the whole body of historic carving as his master. He arrives now at a stage which in traditional times did not come until late in life, when "after the master dies, the student . . . with all the knowledge gained, changes into his own style and does what he really wants to do." In *Eagle Warrior Helmet* Bob draws upon formal art training, study of historic carvings, and family tradition. "I'm a Wolf," he proclaims. "That's my crest, the Wolf and the Eagle, and we are Tlingit and Tahltan people." *Eagle Warrior Helmet* is both a personal and a social artistic statement.[3]

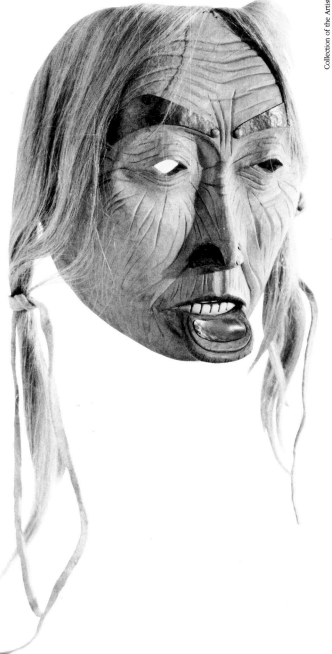

Dempsey Bob notes that "To really understand the art, you have to understand the culture, and the history." Among the Indians of British Columbia, as among most traditional people, age is revered as a sign of understanding and accomplishment, wisdom and continuity. Dempsey Bob was born into such a society at Telegraph Creek, on the Stikine River in British Columbia. To appreciate the work of this young artist, one must appreciate the culture into which he was born and for which he is an artistic spokesman. To such a society the mask of an old woman is more than an element of ritual drama and dance. It is an homage to age, as well as a reverent personal portrait. Bob's mask should be compared with a number of historic masks of old women.[1] While the essential design is similar, including the extended lower lip, the individuality is equally apparent.[3]

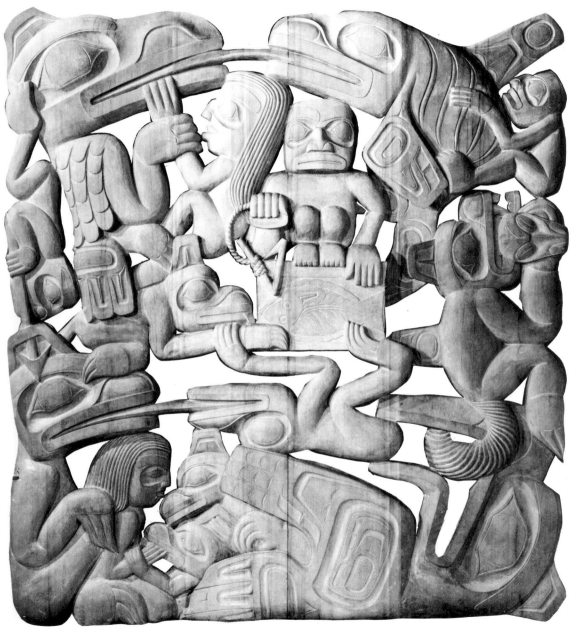

BILL REID, b. 1920

Haida
Mythological Screen, 1968
Red cedar, 84 x 75 x 6

Bill Reid is a rare artistic soul — a revivalist of ancient Northwest Coast art forms who is also an innovative and creative craftsman. Reid builds upon historic Haida sculptural forms in wood, metal, and slate. One of Canada's most honored artists, he works in a range extending from abstract jewelry to traditional Haida housefront poles. He has made both exquisite miniature brooches and a four-and-a-half-ton carved wooden sculpture. He creates in red cedar what Haida craftsmen achieved in tiny, intimate, argillite pipe carvings. Reid's great achievement in *Mythological Screen* is the brilliant braiding of figures made even more complex because it occurs within a square rather than within the traditional horizontal field. The screen, however, is more than a visual design. It speaks. It tells the story of at least five Haida myths. Drawing together the sculptor's art with that of the storyteller, Reid fulfills the carver's historic mission of transmitting the culture.[1]

DONALD MONTILEAUX, b. 1948
Oglala Sioux
Attack, 1980
Watercolor on hide, quills, 36 x 39

Donald Montileaux's *Attack* is traditional yet strikingly modern. Economy of line and richness of color combine to produce action and movement in a style of hide painting too often perceived as static. Like many young Indian artists, Montileaux has considerable formal art training, including work with Oscar Howe and at the Institute of American Indian Arts. He moves freely from the world of historic expressionism, where he draws from the designs and themes of his Sioux ancestors, to the world of abstract symbolism where he transforms these ancient elements into haunting futuristic canvases.

Attack recalls an ancient time when individual prowess, intellectual and physical, commanded great respect. Young Plains artists are captivated by the bravado of their warrior heritage. Yet unlike the assertive horsemen demanding attention, these artists await our acknowledgment.[4]

RANDY LEE WHITE, b. 1951
Sioux
Custer's Last Stand Revised, 1980
Mixed media, 72 x 96

Randy Lee White uses nineteenth-century Plains pictorial style to record a twentieth-century event. In *Custer's Last Stand Revised,* White recalls the clash with technology that occurred when white businessmen first sold junk cars to the unwary Rosebud Sioux. The Sioux had no experience with the motor car and its never-ending need for gasoline. Cars they had; gas they lacked. The artist humorously captures an early Indian version of the energy crisis. All over the reservation dearly-bought chrome steeds are rusting away. In this fantasy version of a modern legend, warriors assault the white double-dealers. Though he uses modern airbrush and canvas, White is true to the symbolic and iconographic integrity of nineteenth-century Plains art. Cars have replaced horses, tire tracks are left instead of hoofprints, and gas pumps stand in place of shield tripods. The stylistic treatment and aerial perspective, however, spring directly from ancient conventions of Plains aesthetics.[5]

TRADITIONALISM

TRADITIONALISM—*known for its flat, two-dimensional representation of historic native scenes—was taught and encouraged by white patrons such as Dorothy Dunn and Oscar Jacobson. Traditional pictures generally portray an idealized version of earlier Indian ways, using areas of smooth color surrounded by darker outlines. Traditional painters have gradually evolved a style that seeks absolute accuracy in historic detail but has become increasingly dramatic in theme and less stylized in form, particularly with the addition of background and perspective.*

ARCHIE BLACKOWL, b. 1911
Cheyenne
Buffalo Hunt, 1980 *Cheyenne Arapaho Family,* 1980
Tempera, 29 x 23 Tempera, 18 x 31

The idealized buffalo hunter is the quintessential subject for traditional Plains Indian painting. The buffalo was the central element of the free-roaming hunter's life, and the disappearance of the great herds continues as the central metaphor in both white and Indian interpretations of westward expansion. Archie Blackowl's *Buffalo Hunt* conveys strength, unity, continuity, and respect for the past. Blackowl was raised by his grandparents in a traditional lifestyle reaching back into the mid-nineteenth century, but the quest symbolized by the buffalo hunt continues to be relevant for young Indians raised in cities and on farms. As Virginia Stroud, a young Cherokee artist, notes, "If you see a scene of warriors traveling across the plains, the artist is looking for where he belongs — traveling in a very real sense. A hunting party returning home may mean the artist is looking for his home." Blackowl's generation of traditional artists is important as the link between past and present. As Blackowl says, "What I know is what I've taken part in. I don't just pretend. That's the way we still live today. We have attorneys and doctors, but we still live the way we did from the beginning."

A few painters of the traditional Indian style continue to practice the art almost unchanged. The continuity is particularly appropriate to the subject matter of the family, still at the heart of Indian life in the 1980s, as it was in the 1880s in which Blackowl has set this work.

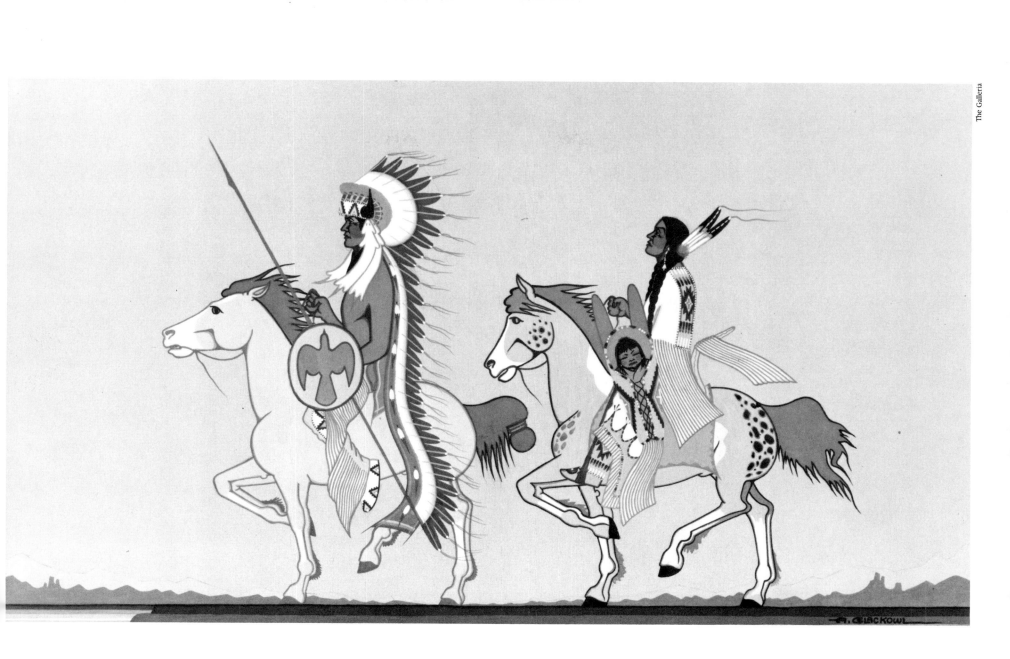

HARRISON BEGAY, b. 1917
Navajo
Squaw Dance, 1974
Casein, 29 x 23

In a note about paintings he entered in the first Philbrook Indian Annual, (Tulsa, 1946), Harrison Begay tells us that he is interested in painting the dances and ceremonies of everyday Navajo life because they are so rarely seen by people other than the Navajo. This interest continues to the present. Like many traditional painters, Begay does not limit himself to the idealized past but seeks to record the "Navajo now" as well as the "tribal then." He has clearly asserted the here-and-now nature of his art and its role as a window on what is otherwise a closed spectacle, known only to its participants. Thus he becomes a spokesman for the traditional Indian artist — and particularly the Southwestern painters — who paint of and for today.[7]

VIRGINIA STROUD, b. 1949
Cherokee
Old Flames — The Navajo Squaw Dance, 1980
Watercolor, 29 x 22

The work of Virginia Stroud is as much a homage to Indian art, artists, and artistic styles as it is a graphic depiction of events of Indian life. It is as if she has mastered all the old styles — ledgerbook, pictographs, and traditional studio — in order to free herself to make her own contemporary statement. In the process she draws strength from the artistic traditions of the Indian painters in the way so many Indians draw upon a legend and experience. Stroud's work thus has a dual thrust. Her work transcends tribal boundaries — drawing as it does on Woodland, Plains, and Southwestern themes — and rigid artistic schools. *Old Flames* depicts highly stylized Navajos in a warm and whimsical way. The persistent softness and fluidity of her work relaxes the viewer. Her vision is optimistic and unabashedly joyful.[8]

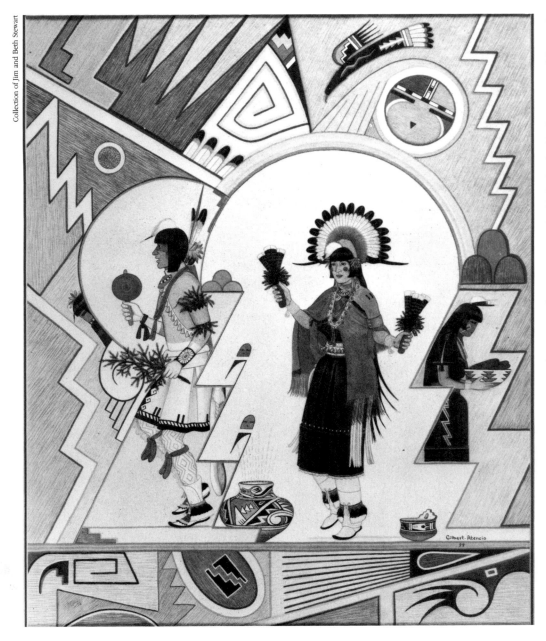

GILBERT ATENCIO, b. 1930
San Ildefonso
San Ildefonso Pueblo Cloud Dance, 1977
Tempera, 27 x 22

The work of Gilbert Atencio vividly illustrates the dynamism of traditional Indian painting. Far from static, Southwestern Indian painting has evolved from single-figure dancers and symbols borrowed from pottery into elaborate village scenes and sophisticated compositions, whose abstract borders and historic motifs compete to fill both foreground and background. Nonetheless, attention to detail and fullness of color in these stylized abstractions suggest that renewal is based upon ancient Pueblo design rather than Western or European nonrepresentational schools. *San Ildefonso Pueblo Cloud Dance* focuses inward, repeating the lines and colors of the dancers. The pottery and costumes in the ornamental border suggest a far greater sophistication than does the simple execution of design, which some critics regard as a static element of traditional painting. Atencio's work speaks to the continued vitality and originality of traditional Indian painting.[9]

MILLARD DAWA LOMAKEMA, b. 1941
Hopi
Two Horn Priest with Maiden, 1978
Acrylic, 50 x 48

Lomakema, a member of the Hopi artist group known as *Artists Hopid,* has described his work as "abstract design in traditional style." An initiate of the Hopi One Horn Society, he is most successful in evoking the spiritual and symbolic aspects of tribal life. His work, like the best of any art, addresses universal issues in the context of a specific and familiar setting. Working in acrylic on canvas, he has created in *Two Horn Priest with Maiden* an important allegory with the duality of male and female, earth and sky, against the backdrop of corn and sun. This canvas opens out with a majesty of color that affirms the continuity of life and the potential of the human spirit. Note the contrast between Lomakema's painting and that of Atencio. The two works approach essentially the same figures in distinctly different ways. Atencio's dancers, as with most Rio Grande depictions, are stately, removed, and noninteracting. They speak of dignity amidst beauty. Hopi artists like Lomakema, however, are concerned with interchange. As priest and maiden exchange the sacred blue "piki" bread, the male and female elements are symbolically joined in a Hopi image of sacredness and fertility.[10]

ANDREW TSINAHJINNIE, b. 1918

Navajo

Pastoral Scene, 1971 *Card Game,* 1978-1981
Tempera, 20½ x 32 Tempera, 31 x 38½

Few traditional painters conjure spirit of place with the subtlety and sureness of Andrew Tsinahjinnie. The originality for which he is praised is evident in his choice of subject matter and its treatment, and in his unconventional palette. Quick action, sustained motion, or inertia — the brush follows mood. *Pastoral Scene* evokes the vastness of the Navajo land. It captures that sense of isolation which draws family together in a way seen by the outside world as Navajo clannishness but felt by the Navajo as their sense of tribe.[11]

Just as Tsinahjinnie's *Pastoral Scene* creates the sense of isolation and independence characteristic of the Navajo, his *Card Game* captures the tribe's basic sociability in a way which surprises those who do not know them. Those who view traditional, flat-style paintings as cardboard works composed of paper dolls should note with surprise the sense of individual, human personality and the collective tribal psychology which Tsinahjinnie captures within the artistic confines of the old school.

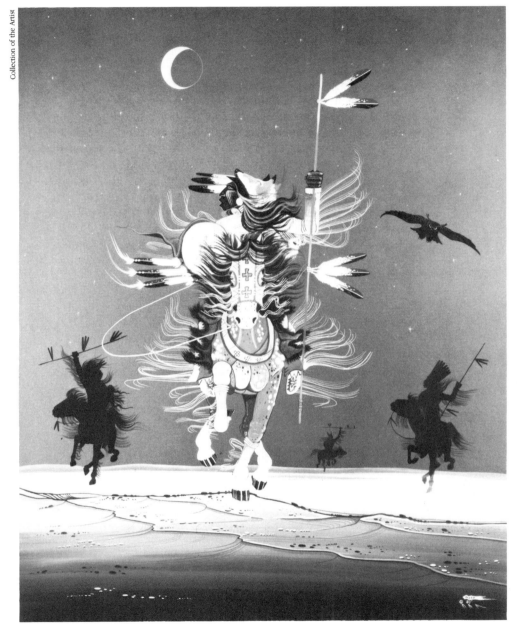

RANCE HOOD, b. 1941
Comanche

Coup Stick Song, 1980 *His Last Chance,* 1980
Tempera, 40 x 30 Tempera, 40 x 32

The paintings of Rance Hood are a logical extension of the theatrical adaptation of original Plains painting. Action has been added and color intensified, but the nostalgic recollection of an idealized Indian world remains. Details are refined, and background and supporting cast are now included. In discussing the influence and evolution of Dorothy Dunn's studio style painting, Allan Houser noted the importance of the personal aspect of painting. He concluded, "Blackbear Bosin got a lot from Quincy Tahoma, but it's original. Blackbear made it his own. And now Rance Hood has gotten something from Bosin. That's fine. It took us time to realize that we had to find ourselves as artists." Hood, like other traditional painters, is capturing an image of what has been, as a cultural vision of what can be. As Hood explains, "A painting style is a matter of feeling...of mood. I am Comanche; my people were a hunting, warring people, nomads, great horsemen. They were a proud people, a wild people, alive and ever changing, like the land and the seasons. My painting style changes too. It explains itself. I am Comanche."[12]

Rance Hood depicts a lifeway gone before his birth. Some ask whether Indian painters should "be free" to paint events of an Indian life they have not themselves experienced. Others demand that Indians paint only their tribal past and only in a prescribed style sanctioned as "Indian" by early white teachers. The issues themselves are irrelevant. The fact that they still exist shows how far Indian ethnic art must go before its acceptance as a form of valid personal expression.

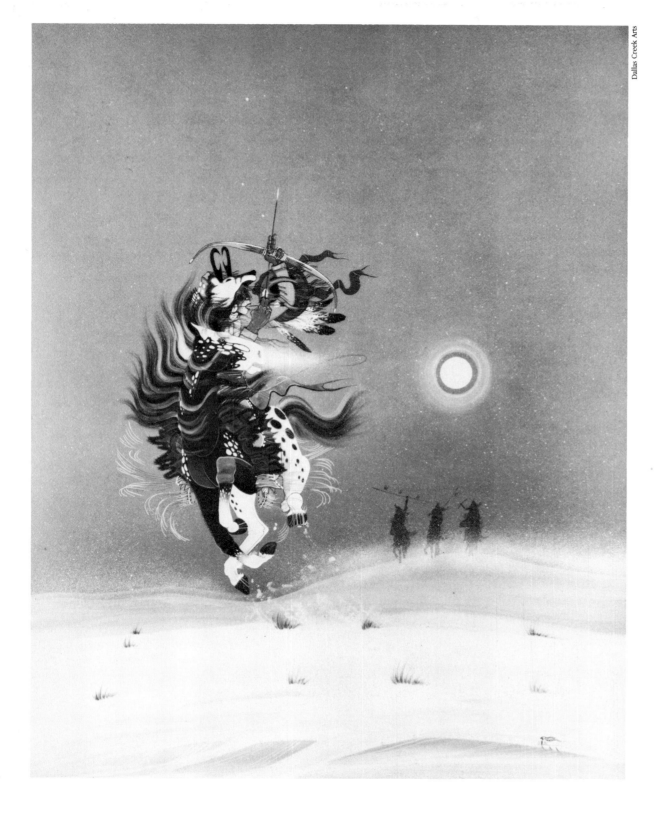

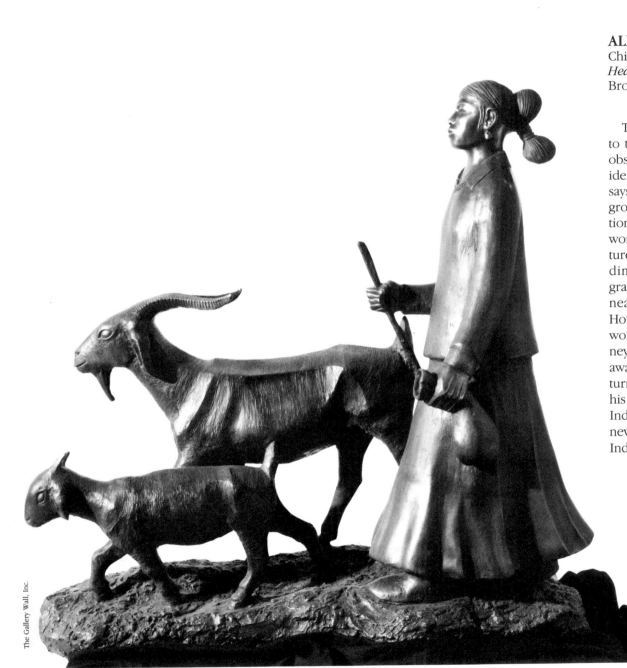

The Gallery Wall, Inc.

ALLAN HOUSER, b. 1915
Chiricahua Apache
Heading Home, 1980
Bronze, 53 x 53 x 22½

The life and work of Allan Houser is a testament to the meaning of modern Indianness. A sensitive observer, Houser takes immense pride in his Indian identity while still perceiving art as universal. As he says, "There are no limits as to ancestry or background in the making of an artist or in the appreciation of his work." *Heading Home* is a monumental work in bronze. One of a casting of six, the sculpture has been described as a study in which "three-dimensional figures move with unrestrained grace." The gentle ease of the forms belies their near life-size scale, suggesting the wisdom of Houser's modest observation that he was made for working in monumental size. The homeward journey is a favorite theme with Houser, who grew up away from the main body of Apaches but still returns to the Apache reservation as the touchstone of his identity. Many of Houser's works, like much of Indian art, are about that journey and the search for new physical and spiritual worlds in which the Indian can be at home.[13]

WILLARD STONE, b. 1916
Cherokee
Exodus, 1967
Walnut, 36 x 36 x 12

Few works of the creative imagination acquire an ultimate life of their own. Willard Stone's *Exodus,* commissioned for the opening of the Cherokee Cultural Center, Tahlequah, Oklahoma, 1968, has become a symbol for the suffering of the Trail of Tears and of the survival power not only of the Cherokees, but of all Indian people, indeed all humankind. Regarded by many as the finest wood sculptor in America, Stone is at his best in monumental works of elegant simplicity where broad sweeping lines convey great emotional depth. The artist describes *Exodus,*

> *Over a trail of tears, reaching from the Great Smoky Mountains to eastern Oklahoma, the Cherokees West were uprooted. In this block of native walnut, from a tree older perhaps than the time of removal, I have tried to capture the tragedy, heavy load of sorrow, and heartache being overcome by a courage and determination seldom, if ever, equaled by any race in history against such heavy odds.*

> *The design is composed of two large teardrops — one balancing the other — on a base representing the contour of the earth for each man's individual trail as he carries his load through his lifetime. One tear drop is composed of his courage and determination to survive in his search for happiness; the other is representative of the heavy load of love in his heart and on his back that he willingly carries in his short time on his long trail.*

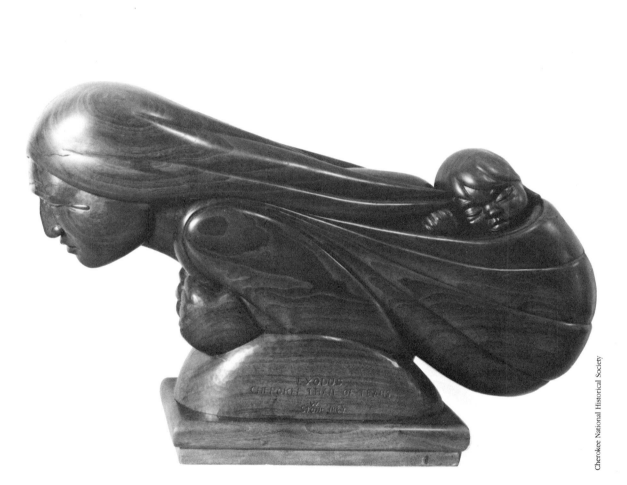

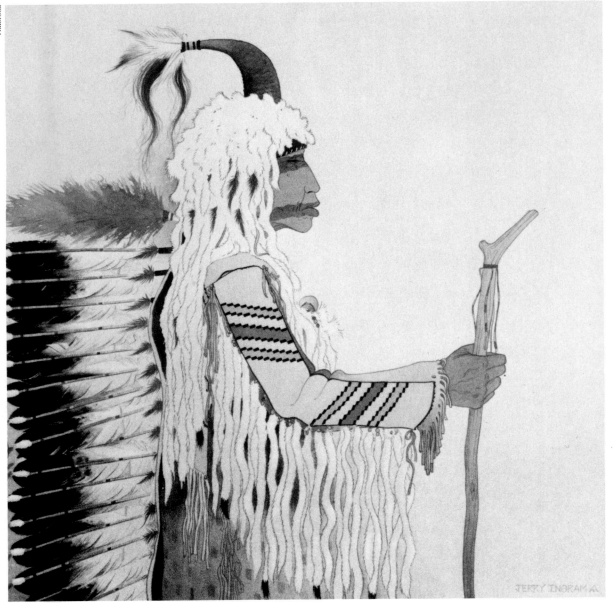

Philbrook

JERRY INGRAM, b. 1941
Choctaw

In Sacred Manner, 1981 *Sign of Strength,* 1981
Watercolor, 10 x 10 Watercolor, 7½ x 11¼

The paintings of Jerry Ingram are the work of an historic romantic. Although suggestive of the traditionalist Indian style, Ingram's work draws inspiration from early frontier artists such as Bodmer and Catlin. His warriors sit as if posed for the artist's brush, drawing us back to the late eighteenth and early nineteenth centuries. Ingram's watercolors are snapshots of life, frozen on paper. The costumes he depicts are wearable, the weapons sharp and dangerous, the reverence genuine. Ingram fashions the war shirt and hammers the lance in paint.

Success poses dangerous consequences for the creative spirit. Actors become bound to successful roles; artists are imprisoned by a popular style. Jerry Ingram, a highly praised "peyote school" painter, remains one of the most experimental of American Indian artists. For years he was associated with psychedelic canvases marked by vivid color, meditative faces, and sensuous water birds. His more recent romantic exploration of historic Plains Indian culture reasserts a long-standing sense of nostalgia. Ingram brings to his Indian portraits a wistful lust and respectful virility that Bodmer and Catlin only rarely achieved.[16]

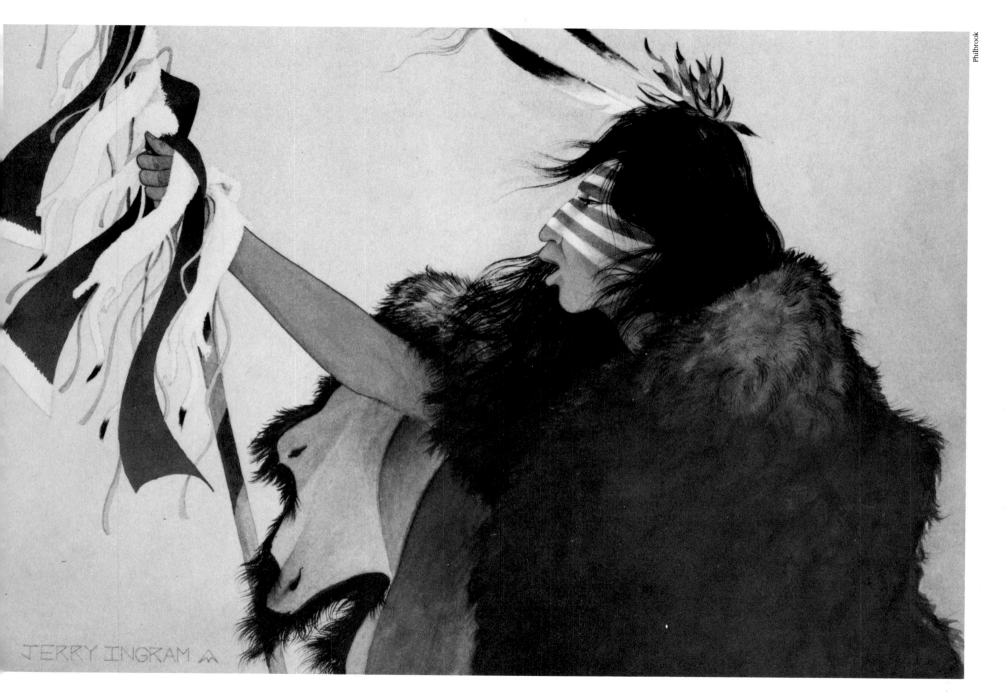

JERRY INGRAM

51

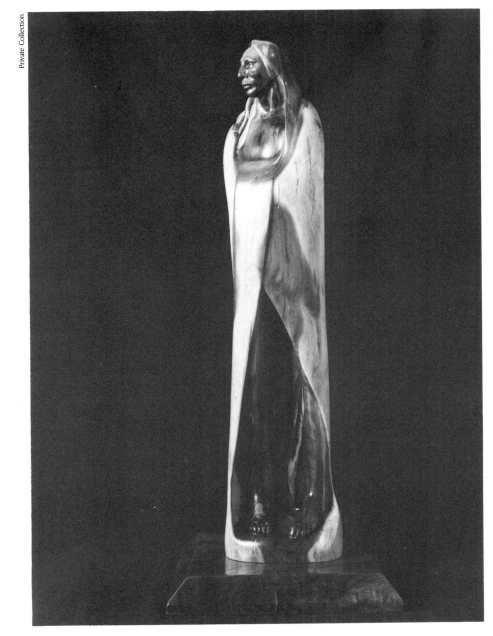

W. RICHARD WEST, b. 1912
Cheyenne
After the Sweat, 1981
Cedar, 24 x 5½ x 4½

The history of the modern Indian art movement
is mirrored in the career of Dick West. Perhaps
more than any other living Indian artist, West has
explored a variety of styles and techniques. He has
purposely kept open to influences from outside his
work and developed them in a personal manner.
While respecting the dangers involved, West sees
the exposure to new channels of expression as
important to the contemporary vitality of Indian art.
Like his fellow sculptor Allan Houser, West has
sought a universality, a timelessness of topic and
mood. The simple nobility of West's wood carvings
celebrates anew the strength and spirituality of the
Indian and his world. The serenity of *After the Sweat*
is a statement about the quest for purification,
whether in ancient Plains ceremonies or in those
revived in the wake of contemporary pan-
Indianism.[15]

MODERNISM

MODERNISM *freely experiments with mainstream contemporary techniques, yet remains visually identifiable as Native American art. It incorporates styles as varied as cubism, surrealism, and photo-realism, yet still portrays Indian motifs and themes—themes spanning an enormous range, from realistic portraiture to bitter social commentary. The modernist Indian artist borrows and adapts from all styles and techniques, following creatively where talent and interest may lead.*

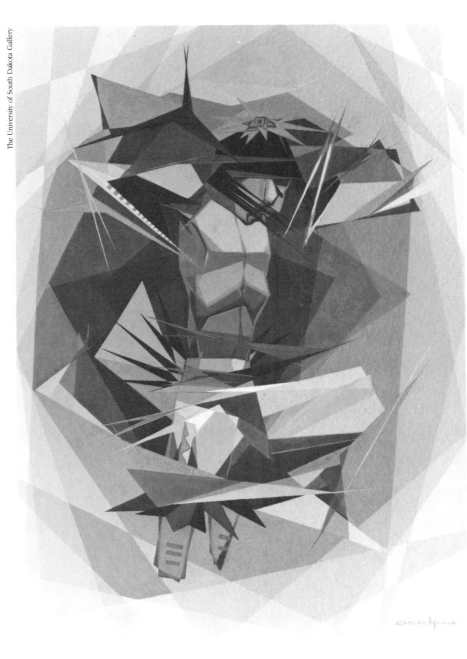

OSCAR HOWE, b. 1915

Yanktonai Sioux

War Dancer, 1967 *Head Dancer,* 1967
Casein, 30 x 22½ Casein, 29½ x 21

Oscar Howe has spent much of his career fighting against a narrow Anglo-imposed definition of Indian art which produces what he called "suppressed art." Asserting that Indian art can compete with any art in the world, Howe has painted a series of cubist abstractions which prove his assertion. At the same time he maintains with equal intensity that the roots of his emerged style are in the Dakota experience and in the old and traditional ways. "Whoever said that my paintings are not in the traditional Indian style has poor knowledge of Indian art indeed." Howe is absolutely correct when one considers the white modernists' acknowledged debt to, even at times their obsession with, primitivism. Oscar Howe's neocubism is a striking example of double cross-pollinization. Viewing one of these paintings is like peering into a series of mirrors where modernism reflects primitivism which reflects modernism and on and on.

Unlike his earlier two-dimensional, studio-style works, Howe's abstract paintings have tension and emotion. This is achieved by a remarkable use of line and by intersection of line with color. Even more remarkable is the Indian feeling, the sense of tribal identity which emerges. Thus Howe can say with honesty that his reason for painting is to carry on the traditional and conventional in Native American art.[17]

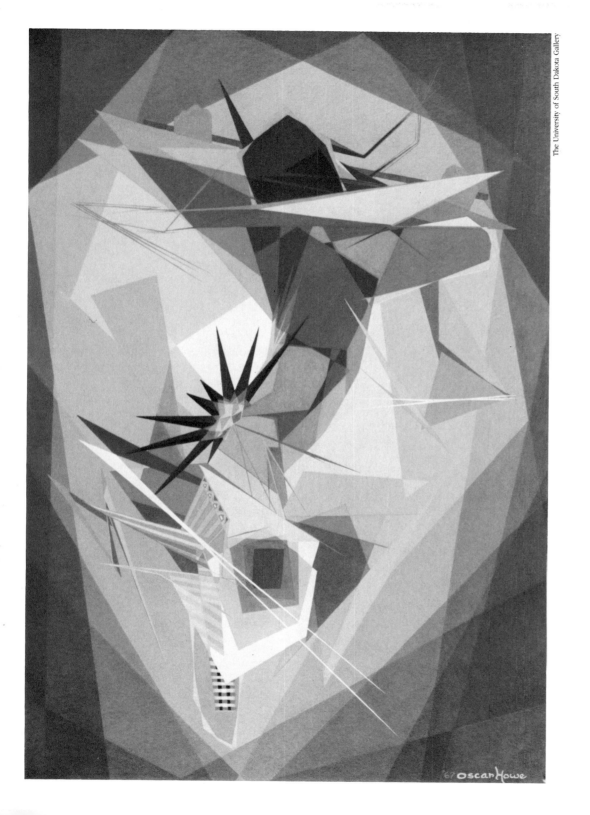

'67 Oscar Howe

The Gallery Wall, Inc.

Water Bird, 1980
Bronze on marble base, 51 x 18 x 4

Eagle Dancer, 1981
Black Tennessee marble
14 x 38 x 22

The Gallery Wall, Inc.

ALLAN HOUSER, b. 1915
Chiricahua Apache

"Doing things that are not completely abstract, but semiabstract is exciting," Oscar Howe explains, "more exciting than doing strictly realistic work." *Water Bird,* a sophisticated abstraction of a major peyote figure, illustrates Houser's belief that "even if I use an abstract approach, the finished piece still has a relation to the Indian." Houser creates an almost metaphysical relationship between the sculpture's raw material and the subject of the work. He looks for this relationship; he evokes it.

The Native American Church — Peyotism — is an immense force in preservation of the Indian identity. This force is apparent in the Teutonic strength of Houser's *Water Bird.* The work suggests a weapon or instrument of defense, as Peyotism and the church are weapons for so many Indian people. *Water Bird* is an important statement of Houser's creed: "Nothing will hold me back. I'm thinking of steel, I'm thinking of concrete. I'm reaching for the stars."[13]

W. RICHARD WEST, b. 1912
Cheyenne
Water Serpent, 1978
Oil, 34 x 30

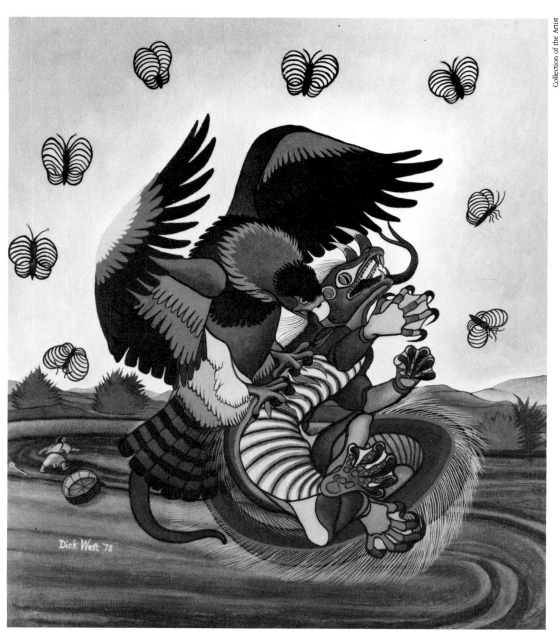

Dick West has always avoided the safe style and the safe subject. *Water Serpent* is at least the third version of the legendary creature that West has shown at Philbrook. A fairly traditional painting of this theme from an earlier Philbrook exhibition is in the collection of the Bureau of Indian Affairs. In describing a highly abstract version now in the Philbrook Art Center permanent collection, Tulsa, Oklahoma, West wrote:

With regard to techniques and treatment this painting in some respects has made deviations from the traditional two-dimensional treatment of the native painting. I feel this type of painting should be considered as much Indian in origin as is his primitive native paintings. This particular approach is an attempt to adapt the American Indian motifs to contemporary pictorial principles. . . . In the past twenty-five or thirty years Indian art has been cultivated and acclaimed. But the subject matter of the traditional painting has been done over and over to the point of becoming hackneyed. Since there is little possibility of growth in this style of painting, the Indian artist must inevitably turn in the direction of more contemporary two- or three-dimensional studies. . . . To demonstrate the numerous possibilities, the painting could vary in style from the comparatively realistic to extreme abstraction.[15]

This version of *Water Serpent* offers yet another evidence of a master artist's struggle to grow.

Elaine Horwitch Galleries

FRITZ SCHOLDER, b. 1937
Mission (Luiseno)
Super Kachina, 1976 *Three Indian Dancers,* 1975
Acrylic, 80 x 68 Oil, 80 x 68

Fritz Scholder — the most widely known contemporary American Indian painter — calls himself a non-Indian Indian artist. Indian art, he says, is art by any Indian. Scholder's paintings, combining what the artist called his version of pop and abstract expressionism, were at one time highly controversial. No longer is this true. Scholder stands in the mainstream of much of American Indian art if for no other reason than that, with his students, he dammed and diverted the old main channel. As he acknowledges, "In a way, I am a paradox. I have changed the direction of so-called Indian painting but I don't consider myself an Indian painter. Although I am extremely proud of being one quarter Luiseno Indian from Southern California, one cannot be any more or less than what he is." Scholder is a particularly important American artist who has continued to experiment at a time when his works were being subjected to harsh criticism and lavish praise. In the long run, his significance may be that he has made us rethink the old clichés about the Indian and to see native peoples in other than their stereotypic noble savage or avenging demon roles. Scholder humanized and revitalized the white man's image of the Indian and, more important, helped restore the Indian's sense of the ridiculous about the white man and about the Indian himself. Laughter is, after all, the beginning of wisdom, and wisdom must surely be at the bottom of great art.[18]

59

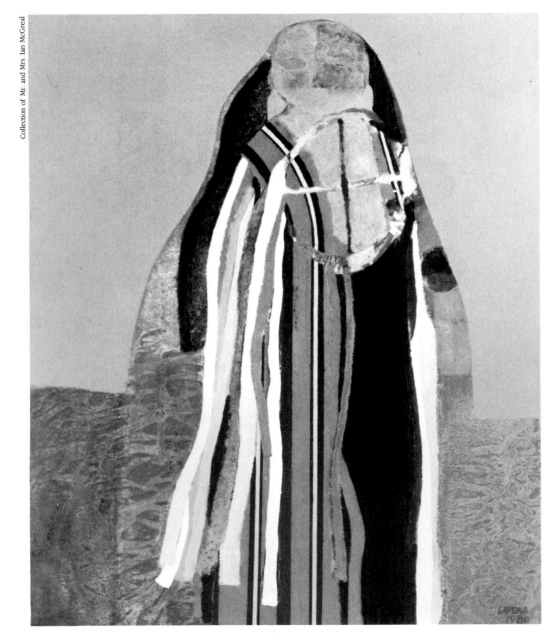

FRANK LAPENA, b. 1937
Wintu

Ribbon Doll, 1980 *Deer Rattle–Deer Dancer,* 1981
Acrylic, 36 x 30 Acrylic, 48 x 34

 This brightly colored celebration of the female is more a universal evocation of woman than a strictly Indian image. Like the Creek-Cherokee painter Joan Hill's *Ribbon Dancers,* this portrait uses flow of line and dynamic of color to elevate an Indian subject above tribe and away from place. *Ribbon Doll* further conveys LaPena's sense of the magical essence of things Indian and the relationship of things Indian to things universal. A mystical apparition of subdued energy and veiled intent confronts the viewer. Just as in *Deer Rattle – Deer Dancer,* LaPena builds upon this visual double-bind to evoke mystery and intrigue. Color and form may convey tranquility, but death imagery and inhuman passivity suggest threat.[19]

 The paintings of Frank LaPena link directly to the mystical tradition in Indian art. They evidence the artist's search for an understanding of power and his relationship to the universe. The dancer in *Deer Rattle – Deer Dancer* is one of the strongest figures evoked in a modern Indian painting. The eyes in the ghostlike skull seize the canvas as do those of a similar figure from Acee Blue Eagle's *The Deer Spirit.* Perhaps as much as any single modern painting, LaPena's *Deer Rattle – Deer Dancer* demonstrates the great continuity of painting tradition despite the changes in medium and style. It also reaffirms, as LaPena notes, that "art and life are reflections of the spirit."[19]

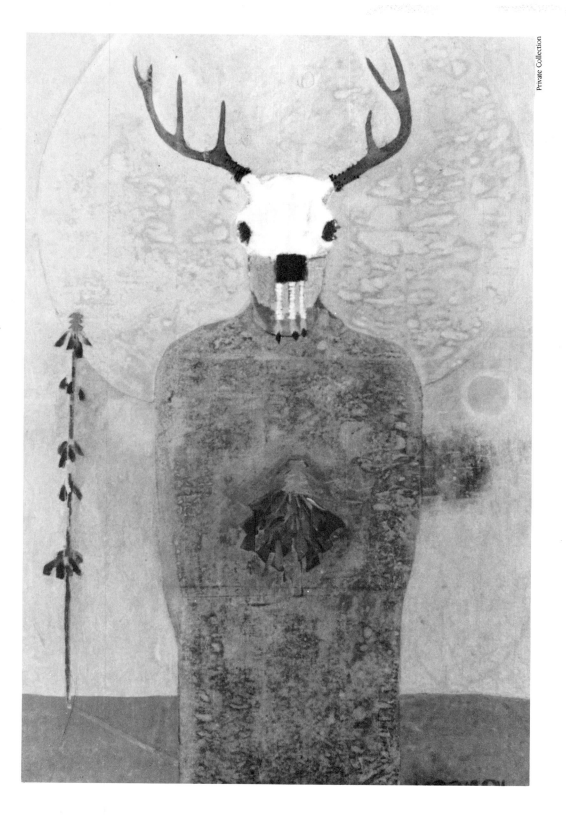

61

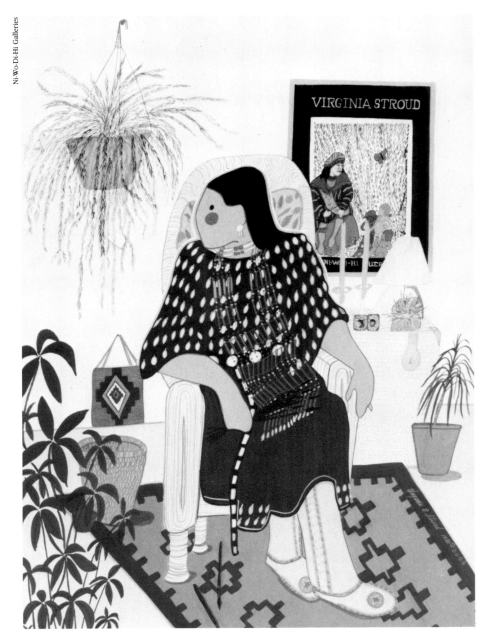

Ni-Wo-Di-Hi Galleries

VIRGINIA STROUD, b. 1949
Cherokee
Where from Here, 1980
Gouache, 29 x 22

Described by the artist as a self-portrait, *Where From Here* is more than that. It is a window on the larger problem of tribal and ethnic identification facing all Indian people. "Indians," Virginia Stroud has written, "live in a world where they always have to explain themselves." Indian painters have often used their art as their statement. *Where From Here* is reminiscent of T.C. Cannon's self-portrayals and of his wonderful painting of the Osage collector in tribal finery resting beside his Van Gogh. Universal as Stroud's statement may be, it is also peculiarly personal when viewed with her autobiographical statement:

> As an Indian, it's difficult to learn the lessons society teaches us. You work, you accomplish, and you improve your standard of living, and then non-Indians say you aren't Indian anymore. You get criticized from both sides. Art is the link. It is the way I can communicate my feelings and my ties with the traditions. Without that link, many people, sensitive collectors and especially the artists, would be really lost. Without anything to paint and record, we would be drifting, searching for where we fit in.[8]

LINDA LOMAHAFTEWA, b. 1947
Hopi/Choctaw
Night Parrot #2, 1981
Acrylic 22 x 30

The most ancient artifact that Willa Cather's bishop found when he went among the Indian people of New Mexico and Arizona was a carved wooden parrot. In this starkly bright and decidedly modern painting, Linda Lomahaftewa captures a parrot in flight, uniting the bird of ancient adventure and light with a sky of modern mystery and darkness. As an exercise in design, this painting is particularly successful at balancing color and line. In addition, the work seems hopeful. Like most of Lomahaftewa's art, *Night Parrot* is a strong statement, expressively Indian and openly optimistic.[21]

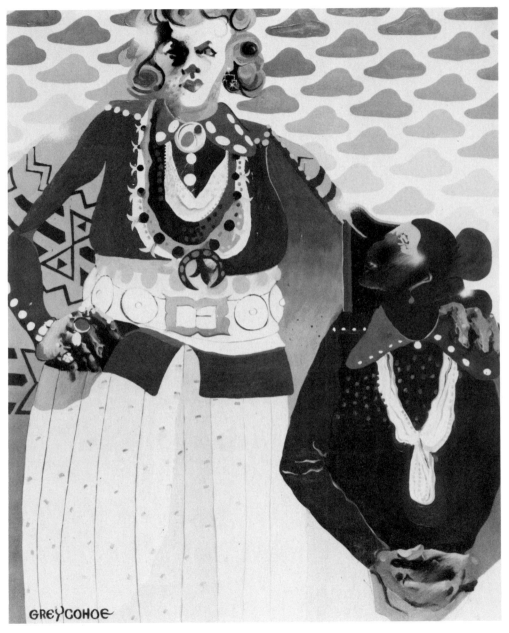

GREY COHOE, b. 1944

Navajo

Tall Visitor at Tocito, 1981
Oil and acrylic, 60 x 48

Tocito Waits for Boarding School Bus, 1981
Oil and acrylic, 50 x 39

In *Tall Visitor at Tocito,* Cohoe's biting brush goes to the heart of the Indian experience with white "Lady Bountifuls" of the mission board or the arts and crafts commission. This painting is in the satiric tradition of Woody Crumbo's *Land of Enchantment* with its exaggerated New Mexico tourists ane Fred Kabotie's murals of drunken and dreaming whites at the Bright Angel Lodge of Grand Canyon. Cohoe's colors and burlesqued anatomical proportions capture the wryest aspects of the ubiquitous "friends of the Indian."

In *Tocito Waits for Boarding School Bus,* Cohoe again addresses an experience which is uniquely Indian. Here we see a strong grandmother figure clutching a small boy. At first glance one is struck by the enormous vitality of the color and the scene appears homely and accessible. But upon a closer look one sees the underlying images of jeopardy and fear. The hands of the grandmother figure are like claws; something suggestively red trickles down the boy's chest. A malignant shadow falls behind the grandmother and in it sits a cat — a witch image in Navajo mythology — with a twinkling eye. In the synthesis of friendly color and hostile imagery is all the uncertainty and apprehension of the Indian child who is sent unprepared into a white world. Thus the painting becomes a metaphor for the clashing of two worlds.

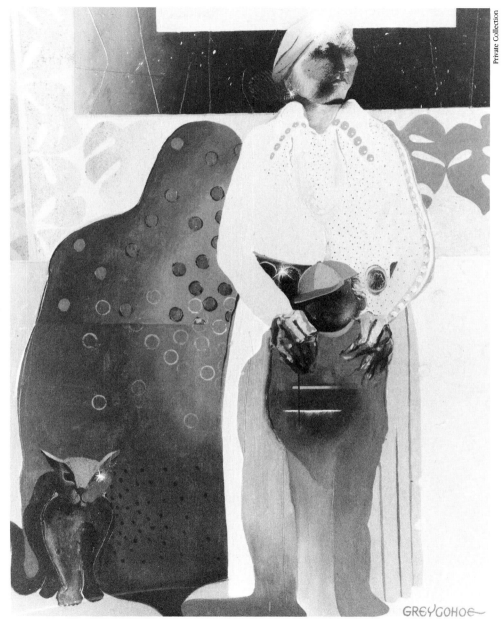

In his verse *Singing Sun,* Grey Cohoe writes,

i sing to offer my corn pollens.

When this Navajo paints in his "silent language," he is, as he explains, striving for a fusion of statement and style based not on realistic or representational subjects, but on application of mixed media. Paintings such as *Tocito Waits for Boarding School Bus* are highly autobiographical. They speak to the whole Indian experience of education as a colonial and reforming exercise designed, as proponents acknowledge, to "destroy the Indian" and "preserve the man," to make red children white in thought and deed. This painting suggests both the horror of the experience and the ultimate doom of the white reform effort.[20]

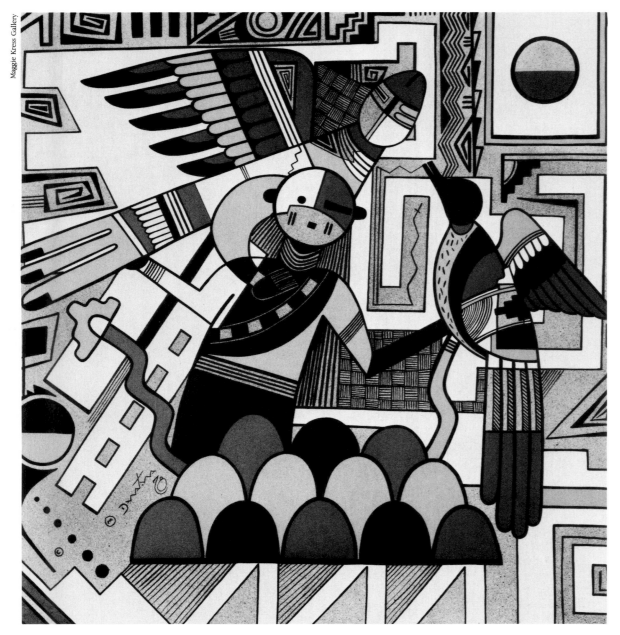

MILLARD DAWA LOMAKEMA, b. 1941
Hopi
Untitled, 1978
Mixed Media, 34 x 34

Lomakema has described one of his most popular painting styles as "abstract design in traditional style", and in a sense his work illustrates the antiquity of what critics call modernism in Indian art. *Untitled Hopi Design* uses ancient symbolic motifs suggesting the prehistoric kiva drawings so influential in Hopi painting revivalism. As Clara Lee Tanner has reflected, this is true of much Indian abstract art, for many of the themes familiar to the Hopi tribe for centuries are repeated in modern art. Here again is the now-familiar ceremonial dancer surrounded by stylized pottery designs. This rendering, however, unlike Gilbert Atencio's *Cloud Dance* and Lomakema's more realistic *Two Horn Priest with Maiden,* has moved a step further toward abstraction. A supernatural figure and his companion birds arise from a storm cloud. The imagery in this design differs from that in earlier works but remains compatible with them in concept and configuration.[10]

RANDY LEE WHITE, b. 1941
Sioux
Horse Dance, 1980
Mixed media, 31½ x 47½

Randy Lee White works in a variety of media to create modern paintings that are valid historic extensions of earlier Indian styles. White is a serious student of tribal culture who portrays the power of ancient medicines and spirits for a world he sees as "complicated, and becoming more so every day". For White, Indians are "becoming less strange on a planet that is more unpredictable as time goes by." White's paintings are given validity by his respect for symbols as more than simply artistic images. He is concerned about misuse of symbols by many Indian painters and seeks himself to capture their spirit power. In *Horse Dance,* an ancient Plains horse effigy staff (from the collection of the artist) invades a festive tableau of performers and spectators. White's incorporation of actual artifacts within his paintings reaffirms his dedication to the visual integrity of the symbol.[5]

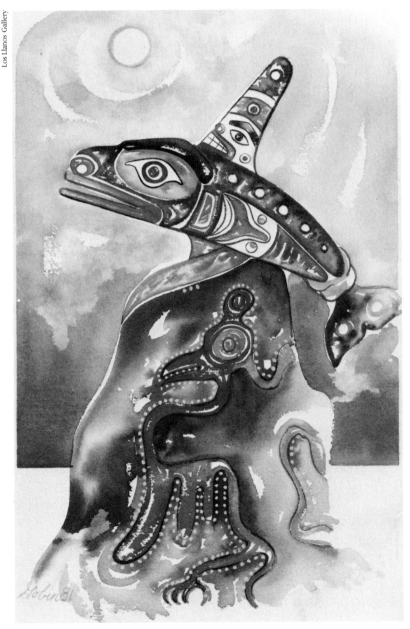

Los Llanos Gallery

HENRY GOBIN, b. 1941
Snohomish
Whale Dancer, 1981 *A Beautiful Tlingit Woman,* 1981
Watercolor, 20 x 14 Watercolor, 20 x 14

Henry Gobin has passed through many so-called schools of Indian painting, moving from the two-dimensionalism of the pre-Institute Sante Fe Boarding School through what he describes as "the world of surrealism" to "stylized faces and masks of the extreme Northwest Coast." Gobin likes to think of himself as living in "that distance between the spiritual mask of the dancer and the spirit world beyond," and he believes that this distance and the spiritual world are the source of his paintings. From the Northwest Coast culture, so steeped in ancient dramatic epics, Gobin came naturally to Indian theater and the political hotbed of 1960s San Francisco, with its Indian protests, street drama, and theater of the absurd. In recent watercolors such as *Whale Dancer* and *A Beautiful Tlingit Woman* Gobin seems to have made peace with the "timeless, weathered crevices of aging totems ... that mother earth is slowly reclaiming to herself."[22]

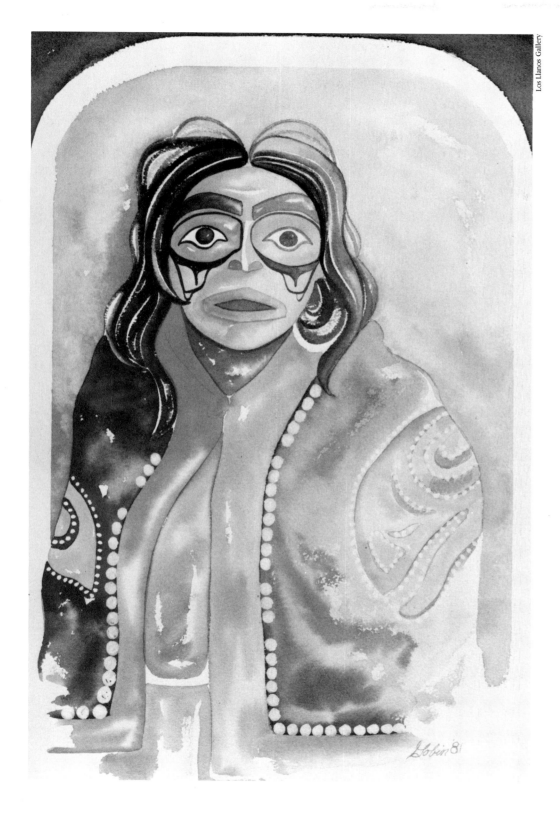

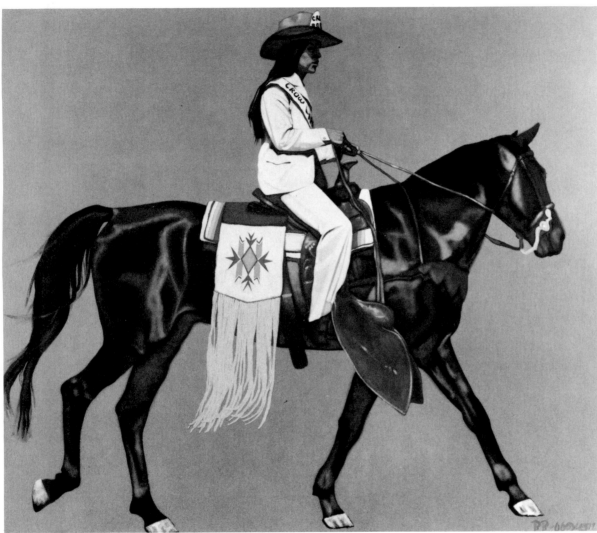

BENJAMIN BUFFALO, b. 1948
Cheyenne
Rodeo Queen, 1977 *Girl on Horse,* 1980
Acrylic, 48 x 54 Acrylic, 36½ x 46

The painting style of Benjamin Buffalo has changed over the past decade as dramatically as that of any American painter. In the early 1970s he explained his art as an "attempt to create a synthesis of the pure, unexplainable, abstract thought processes that occur in every mind in everyday experience." By the beginning of the 1980s Buffalo would say, "I wanted to get away from the traditional, two-dimensional type of work. I'm trying to express the realism of our American Indians by photographic exactness instead of depicting things that are too detailed." Thus Buffalo has emerged as the major Indian exponent of photorealism. *Rodeo Queen* and *Girl on Horse* are as vivid a statement about the evolutionary nature of Indian culture as any works of contemporary Native American art. Anyone who has been to a summer fair, pow-wow, or rodeo knows the ironic testimonial of Indian pride which these paintings convey. Seen in the context of Bob Haozous's *Neophyte Cowboy,* they say much about the cross-currents of culture in the American West.[23]

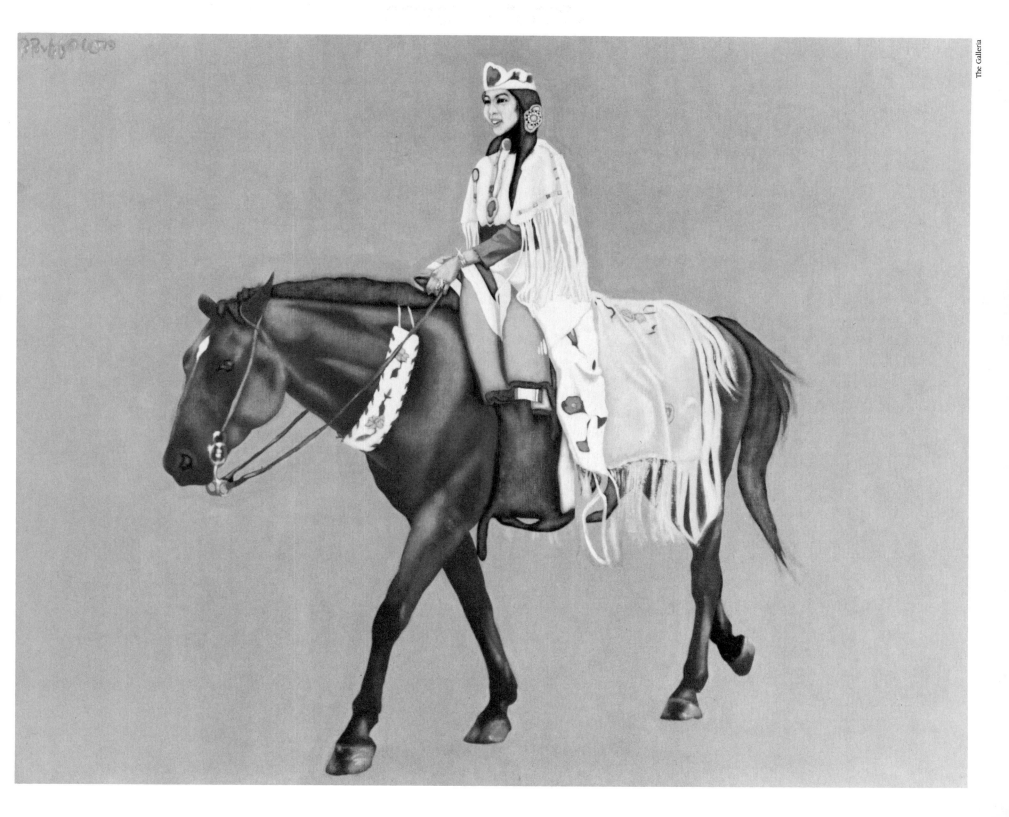

BENJAMIN BUFFALO, b. 1948
Cheyenne
Legal Eagles, 1981
Acrylic, 40 x 44

The issue of Indian legal rights is as central to the modern Indian world as the buffalo hunt was to the old Plains culture. No group of Americans are so dominated by law as the American Indian. In a very real sense, the Native American is at the mercy of the court system, which interprets treaties and regulations both forcibly exacted and freely bargained for. While American Indian painting was undergoing a revolution, a group of Indian "legal eagles" were creating a legal revolution which brought tribal courts back to Oklahoma, restored terminated tribes to full status, guaranteed Northwest Coast tribes an equal share of the fish harvest, and sustained Indian ownership of water rights, including the bed of the Arkansas River. But the law is not new to Indian life. It is as old as the tribes themselves. As the Cheyenne High Forehead told a white anthropologist, before the Blue Coats built guardhouses on the prairies, the Cheyennes kept the peace in their own way.[23]

DONALD MONTILEAUX, b. 1948
Oglala Sioux
Ceremonial Drum, 1980
Mixed media, 14 x 17

The art of Donald Montileaux looks both forward and backward, drawing upon a full range of modern and traditional materials. The artist describes his creative process: "Using my Sioux background as motivation, and using the symbols and designs which were applied to costumes, tipi liners, and shields through the use of beadwork, quillwork, and featherwork, I then transform the designs and symbols through my own ideas." His art speaks in different languages to Indian and non-Indian viewers. *Ceremonial Drum* might suggest to one viewer the drum at a modern Plains pow-wow, particularly in the bells and the tight sleek head and feathers. The buckskin panel to the side might recall another day, long ago, into which the modern dancers are magically transported, leaving behind the small-town football stadium or rodeo sidelot. To other viewers the work may be simply a finely executed graphic depiction of Indian ceremonial objects.[4]

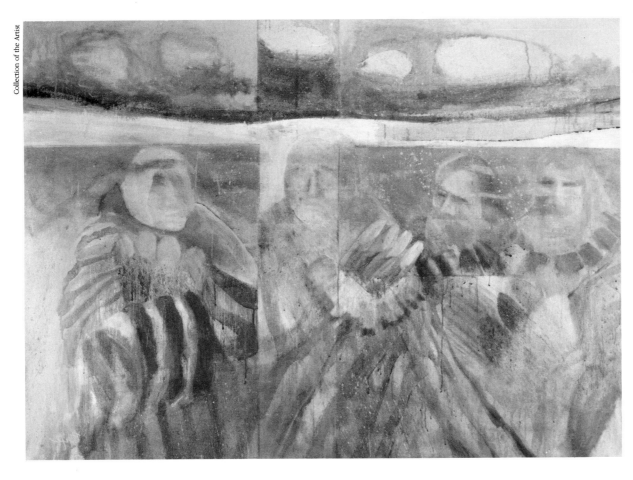

PHYLLIS FIFE, b. 1948
Creek
Canvas Ghosts, 1978
Acrylic, 46 x 62

The classification of *Canvas Ghosts* as an example of Indian modernism is debatable. Is *Canvas Ghosts* a painting with an Indian theme or identifiable Indian images? Are the ghosts Anglos, Indians, monks, priests, or spirits? The feathered fans clutched to the enrobed bodies suggest Indian elders. This alone ties *Canvas Ghosts* to the Indian tradition, and the resulting ambiguity is Fife's intended effect. Unlike Jerry Ingram, a meticulous illustrator of the details of Indian life, Fife wanders the subconscious. Hers is a frosted looking glass, a portal through which either viewer or image may fall. Permanence is illusion on her mental landscape; consistency is fraud. Is the ghost evolving? Is the image blurring as time passes? Are the Anglo and Indian beginning to trade identities? Is this Phyllis Fife's own world of ethnic Indian heritage? Or is this a world of white ghosts trying to manipulate the Indian artist? One thing is certain: these ghosts inhabit a cold windswept plain, devoid of signposts or helping hands. *Canvas Ghosts,* like the modern world of both Anglo and Indian, has no clear way or easy answers.[24]

INDIVIDUALISM

INDIVIDUALISM *is not an Indian art style. It is totally indistinguishable from mainstream contemporary art. The artist is Indian, but the art work is not; at least it is not necessarily recognizable as "Indian." Individualistic Indian artists have a primary allegiance to self, not to a movement or an ethnic group. These artists are frequently criticized for abandoning the Indian tradition in favor of complete artistic freedom. Until quite recently, many critics challenged the right of the individualistic artist to be called Indian.*

JAMES HAVARD, b. 1937
Choctaw/Chippewa

Eagle Egg, 1978 *Dusty Dress,* 1977
Oil, 72 x 84 Acrylic, 64 x 96

As a leading exponent of what has been called abstract illusionism, Havard has earned an international reputation unrelated to his Indian heritage or the world of Indian art. In a sense, Havard's work, as an effort to produce three-dimensionality on a flat plane by the use of flotation and shadows, stands at the opposite end of an Indian art continuum from the flat two-dimensionalism of the studio painters. It is almost as if he were creating acrylic sculpture. As one critic noted, "There is active scribbling and incising into paint causing conflict with the two-dimensional plane and three-dimensional imagery." Havard himself says simply, "I am painting paintings."

Efforts to read Indian symbolic elements into Havard's canvases are academic at best. And yet even sophisticated students of modernism are drawn into his trap when they see "directional arrows and graffiti-style scrawls...reminiscent of New Mexico sand paintings" and "triangles that can be interpreted as teepees and zig-zag patterned bars curved to resemble 'medicine sticks.' " When viewers are thus drawn into the canvas, Havard has begun to achieve his goals as a "painter of paintings." Along with such Anglo artists as Jack Lembeck and Wade Hoefer, Havard has disavowed the sanctity of the picture plane by "objectifying" elements such as brush strokes and lines, thereby giving them substance and tangibility. This very traditional *trompe l'oeil* technique in Havard comes to serve wholly nontraditional purposes.

GEORGE LONGFISH, b. 1942
Seneca/Tuscarora

You Can't Roller Skate in a Buffalo Herd Even If You Have All the Medicine, 1979-80
Acrylic, 86 x 96

Mother Earth Comes to the Rescue of the Brothers, 1981
Acrylic, 86 x 96

The work of George Longfish, an Iroquois trained at the Art Institute of Chicago, illustrates the creative dilemma of the Native American artist who seeks to combine European technique with Indian image or theme. Longfish draws his inspiration from a period prior to the traditional studio painting of this century; he goes deep into Native American history to a time "when art was called artifact." These artifacts, he believes, were "more honest to the feelings of the Indians that produced them." Longfish understands the enormous complexity of his efforts to unite old and new. In describing Longfish's achievements, one critic noted "the extreme difficulty of successfully and convincingly transferring into contemporary art images from another socio-religious context that imbued the original forms with real meaning." The danger, of course, is in splitting symbolic events and ideas from one culture and grafting them onto the artistic body of another. Longfish himself admits that "being in this time and place, it's hard to combine the Indian abstract symbols with modern concepts of painting." However, he sees this happening. And if he is right, all of art — Indian and Euro-American — will benefit.

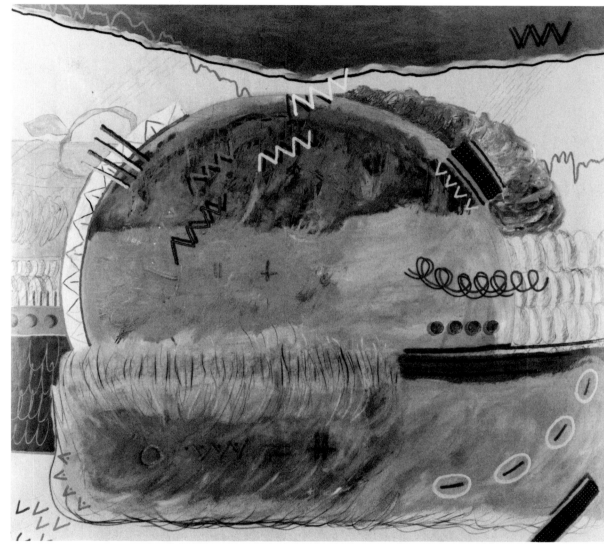

Longfish has opened the visionary door through symbol. Mythic adventures explode upon his canvas. Battles, stampedes, and earth-sundering storms well up to perplex the audience. His archetypal tableaus demand explanation, yet he refuses to comment, leaving the viewer to his own mental archive of universal imagery. His large, unframed canvases hang loosely from the wall, suggesting the freedom and flexibility of old muslin tipi liners. Longfish's paintings are historically rooted, and yet they suggest the perplexities of application of modern technology to universal human issues. Eternal truths and basic values emerge from his works. Longfish actualizes our understanding of the fundamental reality that, even with all of man's new scientific and technological achievements, *You Can't Roller Skate in a Buffalo Herd Even If You Have All the Medicine.*

Clarke-Benton Gallery

JAUNE QUICK-TO-SEE-SMITH, b. 1940
Cree/Shoshone
Horse Constellation with *Camas Series, Untitled,* 1980
Jack Rabbit, 1980 Pastel, 19½ x 28
Monotype, 19½ x 28

Jaune Quick-to-See-Smith describes herself as a "bridge-maker" who draws upon the polarities at the heart of modern life, particularly contemporary Indian life. Her work has been hailed as that of "a university-trained artist [who] is emblematic of an awareness of twentieth-century art including the works of Miro, Klee, and other European artists" but "with a commitment to address her heritage as a native American." Her paintings can be richly narrative while remaining strongly abstract. *Horse Constellation with Jack Rabbit* combines Smith's own personal restlessness with her Indian tribal sense of timelessness, joining old ledgerbook styles with modern expressionism. Smith views the duality of her work as reflective of a holistic, balanced social outlook. "Men are narrative," she explains, "and women are abstract. And I incorporate both."[27]

The works of Jaune Quick-to-See-Smith are philosophical statements designed to provoke thought. Design and color, line, and tone — in every respect the composition of a Smith work is metaphysical. "Building isolated structures to separate oneself from surroundings," she notes, "says something specific — in all cultures — about concentration, privacy, distinctiveness, even ritual." Her symbols may be as indentifiably Indian as a tipi, a headdress, or as universal as the animal tricksters. They are often placed in what she calls "sweet grass . . . bars of contemporary grids". One senses in her work a desire to explore certain ideas and to find a balance between spontaneity and conscious control.[27]

ALVIN ELI AMASON, b. 1948
Aleut

Papa's Duck, 1976　　　　　　*Lay Lady,* 1980
Mixed media, 70 x 59 x 12　　Oil, 62 x 47

 Summarizing his life, the Aleut artist Alvin Amason wrote, "And I still am painting. I love these visual journeys and smoked salmon. You gave me my vision, Papa." His vision is rich, detailed, colorful, and, most of all, whimsical. The young artist's best memories, he says, are of his father and the things his father taught him. This work is a choice memory. Amason seems to wish, as did the hero of Kierkegaard's famous parable, "to always have the laugh on my side." In *Papa's Duck,* he succeeds. Here is a wonderful, bold, ironic statement telling us that art, like life, can be joyful. Perhaps our critical response in the face of the galvanized bucket and decoy is to acknowledge the vision and respond as do the gods to Kierkegaard's supplicant: "Not one of the gods said a word; on the contrary, they all began to laugh." *Papa's Duck* tells us not to take art or life quite so seriously; both may be temporary.

 The painting itself is a classic paraphrase of abstract expressionism *a la* Willem de Kooning. Here is a totally abstract, action-painted background juxtaposed with real "found objects," suggesting not only the artist's awareness of contemporary art styles, but also his audacity in combining two such antithetical modes. One wonders if the work intends something more than a laugh. Could it be a critical comment upon contemporary Anglo art?[28]

If anything suggests that *Lay Lady* is thematically an Indian painting, it is difficult to see. Rather, Alvin Amason has created a vivid and dramatic, almost naturalistic, image which, though uniquely his own work, is no more uniquely Aleut than the works of Picasso are necessarily Spanish. Amason is not slave to any nationalistic or ethnic expression. Nor is Amason's work the chance evolution of native easel painting. Like many of the most talented young artists, Amason is formally educated in the traditions of Western art. He holds three degrees and is widely recognized as a teacher who, like all of us, has a vision shaped by the totality of his experience in the Indian and non-Indian world.[28]

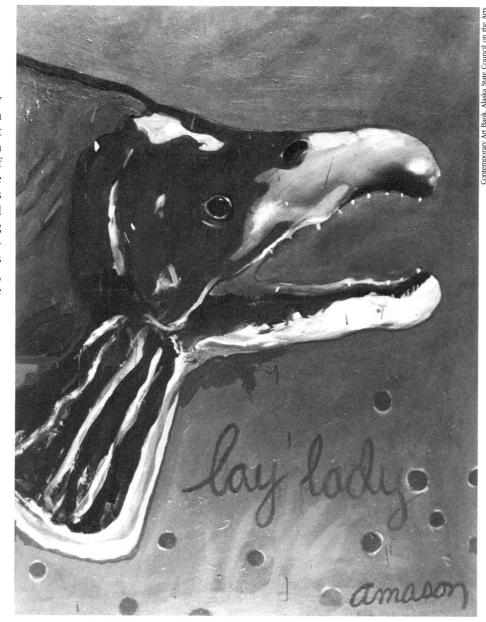

Contemporary Art Bank, Alaska State Council on the Arts

Private Collection

ROBERT HAOZOUS, b. 1943
Chiricahua Apache/Navajo
Neophyte Cowboy, 1981 *New Mexico Landscape*
Limestone, 16 x 60 x 12 *#13,* 1979
Slate, 72 x 36 x 2

"You have to draw from your own personal ex-
perience today," Bob Haozous explains, "not what
you've heard about your culture from your rela-
tives, or patterns and images you've read about."
Thus the son of Allan Houser joins contemporary
and traditional to make a social comment. One
critic has said of his work:

> *Haozous's sculpture has elements of a pop art
> sensibility and a wry wit articulated in a way
> that suggests fairly literal ideas. But within
> each Haozous piece is a spirit that transcends
> the idea. Haozous uses literalness to communi-
> cate a message that is historically cognizant yet
> personally felt. One might compare the duali-
> ties of Haozous's work to the deliberate ambi-
> guities of the art of Jasper Johns, a silence
> within that disturbs.*

Neophyte Cowboy is a table-turning piece. After
all the cowboy artists who have portrayed the Indi-
an myth, it is refreshing to see the cowboy myth
served up by an Indian artist in such a delightful
and colorful way. At another level, when viewed
with Benjamin Buffalo's portraits of Indians as cow-
boys, *Neophyte Cowboy* is a particularly strong com-
ment on cultural adaptation. Rodeoing is, of course,
the major sport on the Navajo reservation, and
much of the cowboy's costume has become a part
of the contemporary Indian's dress. Perhaps
Haozous could be commissioned to do a series
including *Modern Indian as Neophyte Cowboy* or
Cowboy Tourist as Indian Maiden which is hinted
at in *New Mexico Landscape.*[29]

We are all, in a sense, tourists on this earth making a brief journey through life. That Indians seemed to understand this is reflected in their historic desire to blend with the landscape, to become part of nature, not to change it. Robert Haozous's *New Mexico Landscape* shows a white woman in a bathing suit as pot carrier set against a modern New Mexico adobe with picture window. More and more Indian painting is addressing the relationship of white to Indian in the same humorous way white figures were often added to Indian dances centuries ago. It is interesting to compare this slate sculpture with Grey Cohoe's painting *Tall Woman at Tocito*. Surely both are addressing what one student of Haozous identified as a recurring theme — the threat posed by white man's civilization to the Indian way of life. And in Haozous, as in Cohoe, this theme is approached with a humor, complexity, and tension which is at once amusing, thought-provoking, and aesthetically satisfying.[29]

GEORGE MORRISON, b. 1919
Chippewa
Landscape, 1981
Acrylic, 48 x 48

George Morrison has been praised for "the most outstanding record of any Indian painter in the fine arts field". Morrison is the primary Indian exponent of what a Minnesota critic called "that quintessentially American art movement, abstract expressionism." Morrison, now a professor of studio art at the University of Minnesota, was the first and most prominant Indian artist on the "New York art scene" and has always thought of himself as an "artist who is Indian" rather than an "Indian artist."

Looking at his early abstract expressionism, his later wood-collage abstractions, and his more recent relief paintings, one art historian concluded, "George Morrison's art is a search for order. It celebrates the wholeness of order and chaos, instinct and intellect, and man and nature."

Perhaps the best introduction to his painting *Landscape* with its brilliant colors, long lines, and haunting texture is Morrison's own description of the meaning of Indianness in his art:

> *I'm not religious in the usual sense. My art is my religion. I've tried to unravel the fabric of my life and how it relates to my work. Certain Indian values are inherent—an inner connection with the people and all living things, a sense of being in tune with natural phenomena, a consciousness of sea and sky, space and light, the enigma of the horizon, the color of the wind. I've never tried to prove my Indianness through my art. And yet there remains deep within some remote suggestion of the earth and the rock from which I come.*[30]

PHYLLIS FIFE, b. 1948
Creek
The Poet in Painter's Clothing, 1977
Acrylic, 66 x 66

Phyllis Fife comes from a family of distinguished Indian artists and educators. They make up a great clan of the creative and thoughtful. Fife herself experiments in almost all media and styles with paintings and graphics that range from traditional to abstract. *The Poet in Painter's Clothing* is a richly crafted and finely executed testimonial to the artistic spirit. The harmony of color, the mist of texture, and the blur of focus evoke a dreamlike world of the imagination in which the poet and the painter are one.

Fife is a practitioner of ambiguity; she will not commit to hard-and-fast forms. *The Poet in Painter's Clothing* is an excellent illustration of Fife's personal landscapes, whose abstract strength lies in their lack of referential symbols.

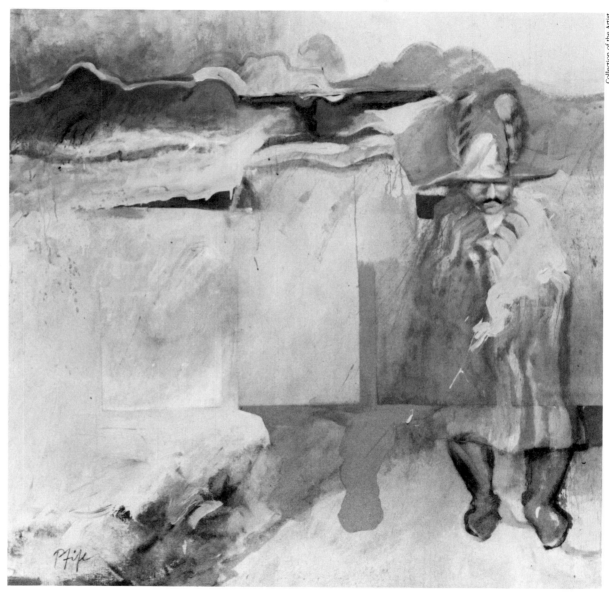

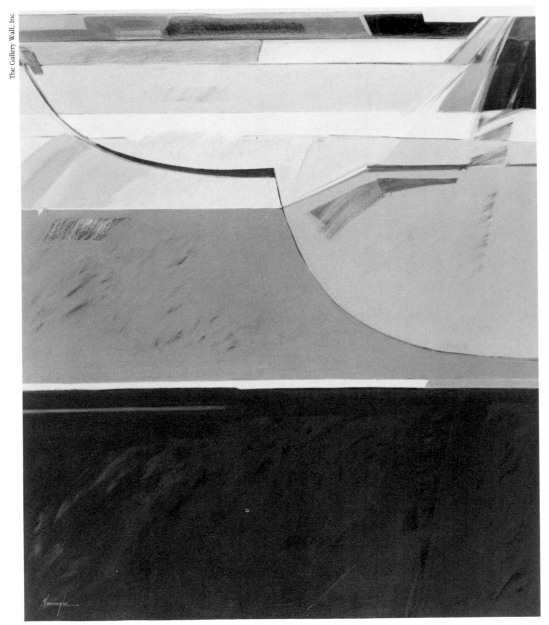

DAN NAMINGHA, b. 1950
Hopi

Mesa, 1980	*Eagle Dancer*, 1980
Acrylic, 68 x 58	Lithograph, 26 x 39¾

"What matters is the color," Dan Namingha explains as he describes what he is trying to do in his large, sunlit, abstract views of the land of the Hopi. "I'm trying to capture the spirit of the land itself." The heir to four generations of the pottery tradition of the famous Nampeyos, Namingha does not regard the ancient and abstract, balanced and geometric pottery designs as the major influence in his painting. He does acknowledge the importance of the tribal experience, the stories and the dances, in his art. When Namingha paints Katcinas, he thinks of them as spirits. When he sees ladders, he thinks of Katcinas descending into the kivas. But, mainly, it is the land he paints and the land which shapes his paintings. As he explains:

> All through my life I've been there, in that area of the Hopi reservation. There's a feeling there for me . . . looking across the far distance from Walpi to Second Mesa. The stretch between those two mesas is flat desert with all its abstract forms. There's so much there to work with. You can find so much in the land. . . . You look at it and at the cloud formations. The clouds cast shadows. Then you look at the rocks, the mesas or buttes. I look at it in sections and as lines. Shadow creates vertical and horizontal lines. . . . There's a lot of texture and cubist forms in there, a lot of play of light and shadow.[31]

The early silkscreens and etchings of Woody Crumbo were precursors of a major and almost revolutionary development in Indian art. Within the last decade or so, graphics — woodcuts, lithographs, monotones — have broadened the world of Indian art both by widening the audience of collectors and expanding the media of the artist. "Graphics," Namingha notes, "are a different medium from painting. You're not sure how it will look until it's printed. It's like a layout. There's an on-going experimental feeling when working on a print." *Eagle Dancer* has the feeling of space and shape characterizing *Mesa* but has, in addition, a greater restraint, refinement, and sophistication. The lines, shapes, and forms combine with subdued color to evoke a very different mood. As Namingha frequently asserts, "I'm experimenting a lot and teaching myself. I allow myself to follow change."[31]

LINDA LOMAHAFTEWA, b. 1947

Hopi/Choctaw
Cosmic Hands, 1980
Acrylic, 48 x 36

One of the most dramatic and popular ceramic pieces in London's *Sacred Circle* exhibition was a sixteenth-century Hopi Sikyatki bowl with a spatter-painted hand. Remembering this oft-used design element of the North American Indian should help the viewer understand the Indianness of Linda Lomahaftewa's paintings. "The subject matter in my work," she says, "is Indian. I use designs and color to represent my expression of being Indian. I think of spiritual aspects of my tribe, and of the American Indian, when I paint. I think of the ceremonies, praying to the sun, and praying for all Indian people for strength and happiness." Iconography aside, *Cosmic Hands* suggests the otherworld orientation and value structure of the American Indian and the unity of this experience with the art of native peoples. It was Thoreau who said that the Indian had the proprietary interest in the moon. Perhaps this work is saying that since the white man has been to the moon he can now hope to understand what the Indian has long known, that salvation rests in a relationship with mother earth. The ancestors have shaped this world, and though departed, their spiritual imprint remains. The ancestors' individuality has fused into a universal totality which is expressed as Hopi, a concept which simultaneously denoted a place, a philosophy, and a people.[21]

NORVAL MORRISSEAU, b. 1933

Ojibwa
The Light Is the Way, 1979
(two panels)
Acrylic, 50 x 124

Norval Morrisseau is considered the founding father of the "Ojibwa-Cree-Odawa School," and is regarded as one of Canada's principal native painters and a profound influence on a whole generation of young artists. Early in his career he stood against tribal leadership and tradition to paint subjects prohibited by his people.

In *The Light Is the Way* an ancient myth is visually rephrased as a pseudo-bas relief. A stately, yet unworldly, procession of transformational beings ritually circles the canvas. Bears, birds, fish, and humans flow in an inexorable tide of purposeful creation, suggestive of Egyptian and Aztec temple murals. The logical spatial and temporal frame has been blurred. *The Light Is the Way* has been described as follows:

> *This two-panel painting deals with the first two of the five levels of man's consciousness. The artist, the central figure in the lower panel, is portrayed as a meditating shaman, surrounded by his young disciples and other creatures that make up his physical world. In the upper panel the ancestral figures of the glorious Ojibwa past are together with the Sacred Thunderbird, underneath the double-headed serpent of life which has spread out its body to form a protective canopy. All the mysticism and spirituality of this vertical diptych is clearly focused on the visionary third eye of the earthbound shaman.*[32]

ALLEN SAPP, b. 1929
Plains Cree
Will Be Home Soon, 1979 *Holding Her Baby,* 1973
Acrylic, 24 x 30 Acrylic, 24 x 36

Allen Sapp is a realistic narrative painter whose subject matter is Canadian Indian life, primarily before the end of the Second World War. Self-trained, Sapp has developed a powerful painterly style that relies heavily upon European and American nineteenth-century precedents. Sapp has been widely honored as a major Canadian artist, elected to the Royal Canadian Academy of Arts, and described as "the first Indian artist on the northern plains who painted his people the way they were during the period of his boyhood."

"I can't write a story or tell one in the white man's language," Sapp reported to his biographer, "so I tell what I want to say with my painting. I put it down so it doesn't get lost and people will be able to see and remember." Working at odd jobs such as woodcutting and living on welfare, Sapp came to the attention of a white patron who encouraged him and arranged art lessons. What has emerged in his painting is a powerful sense of truth which transcends "prettiness."

In his autobiography, Sapp describes a scene similar to the one painted in *Will Be Home Soon:*

> *When I was a little boy I went out sometimes with my grandfather Wuttunee to get a load of wood. In the brush we cut wood, we loaded it up on a sleigh, and brought the sleigh back home. Before I was an artist full-time I used to cut wood and sell it . . . to get money, or trade the wood for food for me and my family. Those were hard times, not like today.*[33]

The mother, or Madonna, and child is a universal and timeless theme. Allen Sapp's *Holding Her Baby* speaks of the depths of motherly love all the more eloquently because this Indian mother, so lovingly focused upon her child, sits amidst such total bleakness. The mother is but a small figure in a composition that suggests a glimpse unobserved into a most intimate moment. The iron bed, the black stove, the kerosene lamp, and the sling for the baby's cradle tell as much about the struggle of this mother as they do about the ethnography of Cree life in the '30s. John Anson Warner has written eloquently about Sapp's paintings. "What we can see in his works," Warner explains, "is a picture of a real people of an Indian reserve who were poor and wanting in most of the amenities of life (and who still are), but who nonetheless possess a sense of themselves. There is no softening of harsh realities of Indian life on his canvases but there is no ugliness for the sake of editorializing either." Sapp's concentration upon everyday life and the ennoblement of hard work is reminiscent of the nineteenth-century French painter Corot, who saw that strength and morality are derived from man's relationship to the earth.[33]

HARRY FONSECA, b. 1946
Maidu

*When Coyote Leaves
the Res* or *Portrait of
the Artist As a Young
Coyote,* 1980
Acrylic, 48 x 36

Snapshot or *Wish You
Were Here, Coyote,* 1979
Acrylic and Glitter, 48 x 36

Although Harry Fonseca has worked in a wide
variety of media and has painted many Maidu
dances and legends, the most popular and widely
known of his work is his series of Coyote paintings.
"Coyote means many things to many people," Fon-
seca has explained, "For me Coyote is a survivor
and is indeed the spice of life." Coyote is, of course,
a persistent figure in Western and Southwestern
Indian mythology, fulfilling much the same role as
Rabbit in the legends of the Eastern and Southeast-
ern tribes. To Fonseca, Coyote is a way to follow the
Indian into the late twentieth century and especially
into the cities where so many Southwestern Indians
were relocated by federal Indian programs or have
chosen to relocate themselves. Fonseca says, "I be-
lieve my Coyote paintings to be the most contem-
porary statement I have painted in regard to tradi-
tional belief and contemporary reality. I have taken
a universal Indian image, Coyote, and have placed
him in a contemporary setting."

There are wonderful contrasts between Fonseca's
Coyotes. There is city Coyote, res Coyote, tourist
Coyote, leather-jacketed Coyote, and mod Coyote.
As more and more of these characters appear and
their personalities develop, a whole new mythology
of modern Indian life unfolds, the richness of the
old ways and the old stories once more providing a
way to understand the new. The Fonseca Coyotes,
consistent with traditional legends, are clever folk
who both outsmart and are outsmarted by their

environment. And the paintings in which they appear are always as mod as the Coyotes portrayed seem to think they are. About them is the element of vitality seen in the Black arts as the southern Negro moved north. Fonseca has been strongly influenced by the funk image centered in the art department of the University of California at Davis, especially the painters Roy DeForest and Joan Brown, and the ceramist David Gilkooley.

Coyote grins, snickers, dances, and cavorts in a conventional world suddenly made absurd by his presence. His antics, however, are not directionless; he is the universal trickster armed with the cutting tongue of the fool. He internalizes and then presents the banality of the easily accepted. He has played a mirror joke, for we are laughing at ourselves.[34]

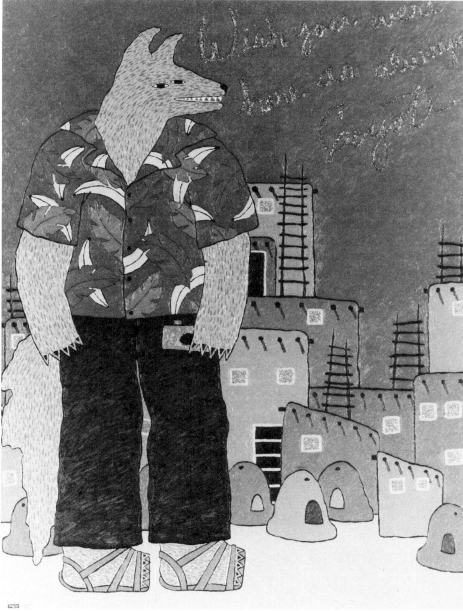

RICHARD GLAZER DANAY, b. 1942
Mohawk
I'll Take Manhattan, 1978
Oil, enamel, mixed media on wood,
10½ x 15½ x 2¾

For those who want to believe that the noble Indian is stoic and unchanging, the works of Richard Glazer Danay are decidedly disturbing. His contemporary creations show the Indian's love of the ironic, the modern, the erotic, and the obscene. A sexuality that traditional artists like Cecil Dick only hint at is boldly displayed in the mixed-media creations of this former high steel construction worker. Both *A Kiss for Ellis* and *I'll Take Manhattan* are urban and urbane works firmly fixed at the gateway to an America which the Indian no longer finds so congenial a home. Danay's works are little jewels with jokes built upon jokes, words playing off words, and ironies building upon ironies. They also tell a bitter story while serving as symbols of survival. *Missionary Headrest,* for example, speaks volumes about repression and hypocrisy, while the backside of *I'll Take Manhattan,* with its wooden nickels and pencil forests, is a grand testimony to centuries of Indian-white relations. A refreshing aspect of these works is that everyone can read them in his own way. What might one say about *Deep Six* or *A Kiss for Ellis?* The viewer's interpretation is valid and the fun of reaching that interpretation is the intentional gift of this artist.[35]

Deep Six, 1978
Oil, enamel, mixed media on masonite,
18 x 8½ x 8½

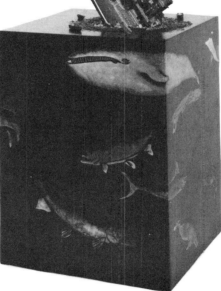

Collection of the Artist

Collection of the Artist

Collection of the Artist

Missionary Headrest, 1978
Oil, enamel on wood,
12 x 9 x 9

A Kiss for Ellis, 1978
Oil, enamel on wood,
8¾ x 5¼ x 2¾

97

Collection of the Artist

JOHN HOOVER, b. 1919

Aleut

Dance Staff Rattle, 1981 *Winter Loon Dance,* 1977-78
Red cedar, 96 x 5 Polychromed carved cedar,
 97½ x 57½

"Like the Shaman," John Hoover explains, "the tribal artist communicates with the spirit world, not just through the finished product, but during the creation of it." To Hoover, this communication is a continuous process. His beautifully carved wooden sculptures are clearly the work of a man in touch with the world of the spirit. Hoover, raised in Alaska by his widowed Aleut mother, is a professional fisherman who did not come to carving until his middle years and continues to fish to assure his absolute creative freedom. "Depending on your art for a living," Hoover has warned, "can be crippling." *Dance Staff Rattle* illustrates Hoover's adaptation of ancient ritual items and shows how, in the artist's words, the Indian's "cultural background . . . his traditional way of life, has a greater influence on the Indian artist than other artists." The figure on the elongated rattle is a beautiful woman, ritualized and stylized but erotic and earthly while maintaining an almost ethereal presence. Other faces are hauntingly set in elongated forms suggesting a mystical possession and the effort to draw upon all of life's spirits.[36]

98 HOOVER / *Individualism*

John Hoover's life and art is touched by the spirit of the loon. "Loons have always followed me," Hoover recalls, "like spirit protectors." His monumental wood sculpture, *Winter Loon Dance* is so delicately balanced and exquisitely proportioned that one feels the movement of the birds. Although eight feet in height and almost five feet in width, *Winter Loon Dance* is as light and free and open as a bird in flight. When scaled down in a photograph it appears to be a crown which stands as the finest demonstration of Hoover's particular artistry. "My work isn't threatening," Hoover explains. "The faces are gentle and peaceful. The images are stylized. To achieve muted color tones and the effect of natural pigments, I mix paints with white diluted with turpentine. I like the soft washes of orange, rust, wood tones, the blue-greens of the sea. The wood that I use is cedar, four or five hundreds years old."

Winter Loon Dance is an allegory on the Dance of Life. To Hoover, Indian art has a "religiosity" that separates it from the work of non-Indians. One sees that reverence in Hoover's dancing loons. The artistic metaphor of Indian art which Hoover describes is apparent in these loons. About his relationship with the loons, the Aleut carver has written:

> *The loons, who never come ashore, hover above the inlet in front of my house, and just as when I was a child in Cordova, I hear their cry morning and evening. They are my friends.*[36]

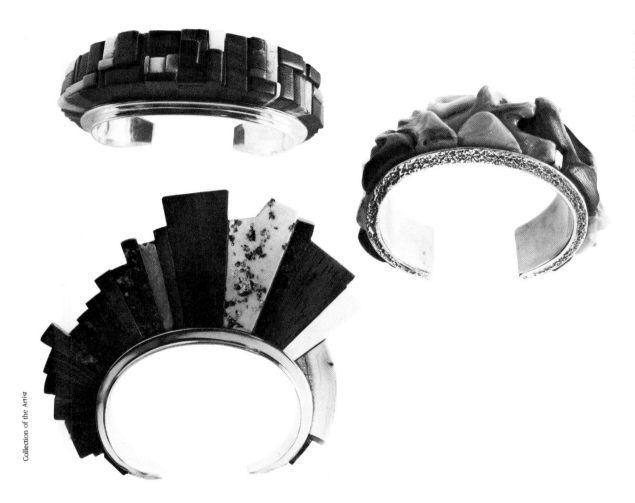

CHARLES LOLOMA, b. 1921
Hopi
Jewelry/Sculpture, 1970-81
Gold, silver, lapis, wood, coral, turquoise, ivory
Six works

When Charles Loloma creates he does not think only of functional rings, bracelets, or pins; he also imagines philosophically emotive sculpture. He has helped redefine contemporary Indian art. His rings and bracelets are closely aligned with the wood sculpture of George Morrison; they echo the same feeling as Dan Namingha's landscapes and eagle dancers.

Loloma's work represents a fusion of abstract modern form with ancient Hopi myth and philosophy. A particularly outstanding Loloma sculptured bracelet utilizes loosely strung turquoise discs which, when the bracelet is moved, lightly fall upon one another. The concept is totally Hopi. Loloma's inspiration comes from the Ancient Earth Mother "Huruing Wahi," or "Hard Being Woman," who dwells amidst the great western ocean in a house of stone, turquoise, and seashells. Here is the power of transformation. At night she woos young adventurers, appearing to them as a beautiful, virginal maiden. In the morning the boys wake to find an old withered woman nestled against their strong young bodies. Such are her gifts. Those who are careless may find that even her wondrous present of radiant turquoise beads has dissolved back into water. Loloma employs this Hopi transformational concept of turquoise as water when he makes the sound of tinkling stone discs an integral component of his sculptured bracelet.[37]

BEYOND THE ETHNIC UMBRELLA:
Learning More About Contemporary Indian Painting and Sculpture

Rennard Strickland

Over the last two decades the art world has debated the "Indianness" of Indian painting and sculpture.[1] In art, as in life, few controversies are really new. The debate over Native American artistic images mirrors the nineteenth-century quest for ethnic, racial, and national qualities in European and American painting.[2] In 1875 a *Scribner's* critic argued that "an American, an Englishman, a Dutchman, an Italian, and a Frenchman, called upon to plant an umbrella, one after another, in the same spot, and paint the same scene, will produce pictures so different from each other, in handling and effect, as to warrant their being presented and preserved in a group upon the same wall."[3]

This historic search for national or racial artistic schools seems outdated, quaintly Victorian. Yet it is at the heart of the contemporary Indian art controversy. The debaters ask, Is there an Indian art style? Is "Indian painting" all painting by any Indian? Does Indian painting require an Indian theme? In short, is the Indian umbrella a preordained form in the Indian mind? We too could assemble a wall of

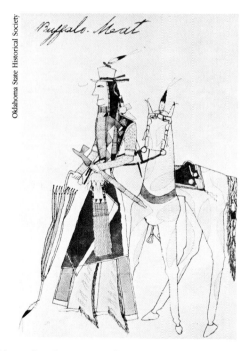

Buffalo Meat's *Self Portrait or Indian with Horse.*

artistic umbrellas created by Native Americans. How, for example, would one compare the ethnicity of the nineteenth-century Cheyenne artist Buffalo Meat in his ledger style painting *Indian with Horse* with the ethnicity of T. C. Cannon in his lithograph *Indian Princess Waiting for the Bus in Anadarko?* Would Fritz Scholder's *Indians with Umbrellas* be more or less truly Indian than Dorothy Trujillo's ceramic figure *Pueblo Potter with Umbrella on Market Day?*[4]

"Art," Georges Braque proclaimed, "is meant to disturb." And much that is happening in contemporary Indian painting and sculpture is disturbing. Many important questions in the Indian painting debate are not easily answered. The conscientious patron seeks self-education to enhance both appreciation and understanding. This essay is designed to help in that process by exploring the major sources of popular scholarship on Indian painting and sculpture with primary emphasis upon illustrated works that provide an analytical and visual experience.

The great American painters of the nineteenth century, when asked how to understand and identify "good painting," told their patrons to look and to look and to look again. One understands and appreciates art by seeing art — both the good and the bad. Art is intended to be experienced emotionally as well as intellectually. This is just as true of a modern Indian abstraction as it was of an Eakins or Chase portrait. The eyes are informed by the mind and heart; the serious student of Indian painting and sculpture wants to know, to see, and to feel. We need to know what the artist is trying to achieve. Thus, we need to be aware of the Indian artistic tradition and the cultural and religious roles art plays in tribal life. Further, we must understand how the Indian has interacted with white culture. As the Indian dips into the so-called mainstream, the broader cultural currents of the Anglo artistic tradition become increasingly strong. If we are to regard Indian painting as more than an ethnographic curiosity, then we must look for more than an Indian subject and a flat, two-dimensional style.

A number of basic books will help us understand the evolution of Indian painting and sculpture. Two works by Jamake Highwater are primary reading and provide an excellent introduction. *Song from the Earth: American Indian Painting* (Boston: New York Graphic Society, 1976) surveys the historical development with particular emphasis upon schools and influences. *The Sweet Grass Lives On* (New York: Lippincott & Crowell, 1980) focuses upon fifty contemporary Indian painters, reproducing examples of their work and exploring their artistic goals. Dorothy Dunn's *American Indian Painting of the Southwest and Plains Areas* (Albuquerque: University of New Mexico Press, 1968) is a serious study and an autobiographical account by the moving force in the early Santa Fe School. Clara Lee Tanner's *Southwest Indian Painting: A Changing Art* (Tucson: University of Arizona Press, 2d ed., 1973) is an insightful volume on the relationship between art and Southwestern Indian culture. A controversial but important study is J. J. Brody, *Indian Painters and White Patrons* (Albuquerque: University of New Mexico Press, 1971), which develops the thesis that traditional Indian painting is primarily a white-directed art. Guy and Doris Montham focus on selected contemporary artists in *Art and the Indian Individualists* (Flagstaff, Ariz.: Northland Press, 1975).

One of the threshold difficulties in understanding Indian painting and sculpture is that contemporary native painting is lumped with all other Indian art. Navajo rugs and Sioux beaded saddles and Salish horn spoons are compared with Kiowa books of ledger paintings and Hopi watercolors of Katcina dancers and Creek abstract oils of desert landscapes. It is thus more difficult to make informed, comparative judgments about Indian painting and sculpture. It is a little like evaluating all European artistic achievement by looking collectively at silver spoons, carved monastery doors, illuminated manuscripts, and the paintings of Claude Monet. Furthermore, there were more than two thousand North American Indian tribes, bands, and groups with more than two hundred languages. Utilitarian, sacred, and ornamental objects come together in our minds under the heading "Indian Art." All have influenced, in some way or other,

T. C. Cannon's contemporary colored lithograph *Indian Princess Waiting for Bus in Anadarko* reflects the ironies of the Plains people as they faced life off the reservation in the 1930s. Dorothy Trujillo's *Pueblo Potter with Umbrella on Market Day* is a lighthearted ceramic self-portrait complete with the potter's basket of bread, her purse, and a tiny mudhead pot ready for sale to a passing tourist.

Private Collection

Private Collection

contemporary native painting and sculpture. But painting ands sculpture must be evaluated as painting and sculpture if we are to understand them and their role in the broader artistic tradition.

Nonetheless, Indian painting and sculpture cannot be isolated from the context of all Indian art. The most popular general pictorial overview is Frederick J. Dockstader, *Indian Art in America: The Arts and Crafts of the North American Indian* (Greenwich, Conn.: New York Graphic Society, 1961). The standard trade book on stone artifacts is the heavily illustrated Charles Miles, *Indian and Eskimo Artifacts of North America* (Chicago: Henry Regnery, 1948). The standard academic text is Gordon R. Willey, *An Introduction to American Archaeology: North and Middle America,* vol. 1 (Englewood Cliffs, N.J.: Prentice-Hall, 1966). An exquisite book with lavish color, Norman Feder's *American Indian Art* (New York: Harry Abrams, 1969), is a handsome general introduction. Two other helpful, although less lavish, works are Andrew H. Whiteford, *North American Indian Arts* (New York: Golden Press, 1970); and John Anson Warner, *The Life and Art of the North American Indian* (New York: Crescent Books, 1975).

Further analytical refinement is needed even when painting and sculpture are viewed in isolation from other native arts. In this house are many artistic mansions. There is no single Indian painting style. Native artists continue to draw in the old hide–ledger-book styles, to paint in the studio traditional mode, to follow trends as divergent as photorealism and abstract expressionism. Almost every school of contemporary artistic expression has an Indian exponent. Beyond that are the Indian stylistic refinements and streaks of individual genius that make Indians leaders whose styles are followed, in turn, by non-Indians. In the exhibition *Magic Images: Native American Arts*, shown in the summer of 1981, Philbrook Art Center presented a wide range of styles in the four categories of historic expressionism, traditionalism, modernism, and individualism. Within each of those categories are almost as many artistic visions as artists. One cannot make a single generalization describing all of contemporary Indian painting and sculpture. Indian artists are

following too many roads.

To understand what is happening in Native American arts requires visiting tribal villages and reservations, museums, and galleries to look and to look and to look. A convenient guide, with bibliography by John Anson Warner, is "American Indian Museums and Information," *Southwest Art* 11:1 (June 1981), 34–37. Other listings of museums, galleries, and reservations are found in Jamake Highwater's *Fodor's Indian America* (New York: David McKay, 1975) and Arnold Marquis, *A Guide to America's Indians: Ceremonials, Reservations, and Museums* (Norman: University of Oklahoma Press, 1974). Similar material is gathered in a two-volume work edited by Barry T. Klein and Dan Icolari, *Reference Encyclopedia of the American Indian* (Rye, N.Y.: Todd Publications, 1973). The Indian Arts and Crafts Board of the U.S. Department of the Interior also publishes listings of Indian-owned and operated shops and an arts and crafts directory.

A supplement but not a substitute for visiting museums is the glorious body of reproductions of American Indian paintings, which can provide the

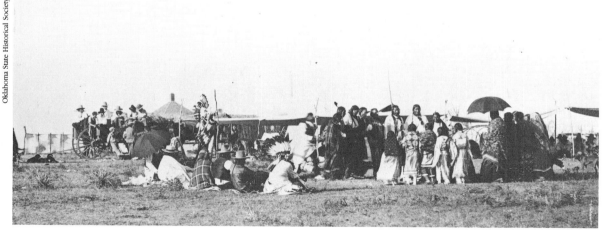

Oklahoma State Historical Society

Indian art mirrors Indian life and such seemingly whimsical details as the use of umbrellas often have historical antecedents as illustrated by this photograph of the Cheyenne and Arapaho reunion held in 1911 near Clinton, Oklahoma.

serious student with the richness of major public and private collections. A series of early portfolios executed in France has been reissued as *Masterpieces of American Indian Painting* by Bell Editions of Santa Fe and Folio, Inc., of Scottsdale, Arizona, with new introductions by Jamake Highwater. These include: Oscar Brousse Jacobson, *Kiowa Indian Art* (Nice: C. Szwedzicki, 1929); Hartley Burr Alexander, *Pueblo Indian Painting* (Nice: C. Szwedzicki, 1932); Kenneth M. Chapman, *Pueblo Indian Painters,* 2 vols. (Nice: C. Szwedzicki, 1936); Hartley Burr Alexander, *Sioux Indian Paintings,* 2 vols. (Nice: C. Szwedzicki, 1938); and Oscar Brousse Jacobson and Jeanne D'Ucel, *American Indian Painting,* 2 vols. (Nice: C. Szwedzicki, 1950). The Highwater introduction to the Kiowa portfolio is a particularly fine analysis of the emergence of the modern Indian painting movement. Color reproductions of native American art fill Patricia Broder's *American Indian Painting and Sculpture* (New York: Abbeville Press, 1981). Other illustrated studies focus upon painting in particular tribal or geographic areas. For example, the Hopis are

considered in Byron Harvey III, *Ritual in Pueblo Art: Hopi Life in Hopi Painting* (New York: Museum of the American Indian, Heye Foundation, 1970), and in Patricia Broder, *Hopi Painting: The World of the Hopi* (New York: Brandywine Press, 1979).

Art on museum walls and in the pages of books is different from art in a living culture. By a stroke of luck we have a chance to see the role that art played in Indian life captured in a remarkable film made by Edward S. Curtis in 1914. This pioneer documentary, now known as *In the Land of the War Canoes,* was the first full-length motion picture on an aboriginal North American society. While the plot is melodramatic, the dances are unmistakably real. When Thunderbird and Grizzly Bear dance, the soul of the animal awakens. There is instant understanding of a vitality we have previously only been told about or sensed intellectually. The dancer is not portraying Grizzly Bear; the dancer *is* Grizzly Bear. Bill Holm and George Irving Quimby, who produced and restored the film, tell the story of Curtis's film and their work in *Edward S. Curtis in the Land of the War Canoes: A Pioneer Cinematog-*

rapher in the Pacific Northwest (Seattle: University of Washington Press, 1980). Curtis captures something of this same feeling in his famous still photographs in Edward S. Curtis, *The North American Indian,* 20 vols. (1907–30) reprint, (New York: Johnson Reprint House, 1970). Another work that suggests the reality of Indian ceremonial art and drama is *The Year of the Hopi: Paintings and Photographs by Joseph Mora, 1904-06* (Washington, D.C.: Smithsonian Institution Traveling Exhibition Service, 1979). One of the best ways to begin to understand this aspect of Indian art and life is to see an Indian ceremonial. One can then begin to appreciate how central Indian art is to Indian life.

In the disjointed art debates over Indian modernism a number of issues have become confused. Whether or not an Indian is an Indian artist when he paints an abstracted umbrella is a different issue from how successfully the Indian artist paints that abstracted umbrella. Some patrons who dislike modernism have decided that only what existed in Indian culture before the twentieth century is an appropriately Indian art form. These patrons search

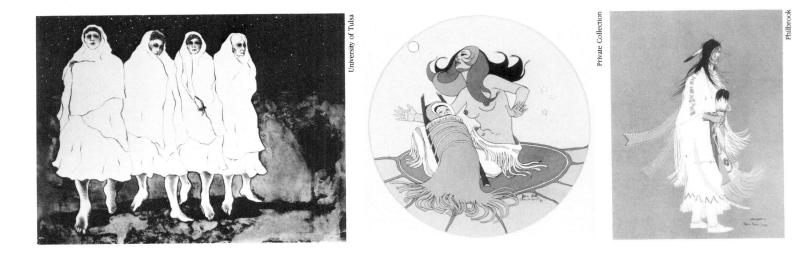

for modifications of historic aspects of the Indian art with which they are comfortable. Seizing on bits and pieces of the whole artistic tradition they have created canons, rules, and tenets for Indian painting. For example, no modeling, perspective, or background is allowed under some of their guidelines. Others demand "artistic freedom" for Indian painters to explore styles beyond the sanctioned tradition. These patrons often extravagantly praise experimentation simply because it is a deviation from the Indian artistic norm. Freedom and quality are often confused by both sides in the debate. It is possible to believe that personal freedom is the essence of art and that Indian painters ought to explore new artistic avenues but also to believe that much of what is being created is ineffectual. There can be mediocre cubist or surrealist Indian painters just as there can be terrible and trite traditionalists. Furthermore, Indian traditionalism, revived and revitalized, may be remarkably alive, while most that is current in European and American art may be moribund.

A number of excellent descriptive essays provide brief introductions to these divergent developments in Indian painting. The most widely read article on Native American artists is Dorothy Dunn's "America's First Painters," *National Geographic Magazine* (March 1955), 349–78. A short but important treatment is Jeanne O. Snodgrass, "American Indian Painting," *Southwestern Art,* 11:1 (1969). A. M. Gibson explores Indian artistic achievement and native culture in "Exaltation of Life: The Art of the Southern Plains," *Four Winds* (Winter, 1980), 49–53, 90–94. Another fine essay with a narrower tribal focus is Gary Galante, "The Painter: The Sioux of the Great Plains," in Anna C. Roosevelt and James G. E. Smith (eds.), *The Ancestors: Native Artisans of the Americas* (New York: Museum of the American Indian, 1979). John C. Ewers, the dean of Plains art historians, traces painting back before the ledger books in "The Emergence of the Named Indian Artist in the American West," *American Indian Art Magazine* 6:2 (Spring 1981), 52–61, 77.

A survey of traditional native arts and the emergence of Indian painting styles is found in Daniel M. McPike and David C. Hunt, "Heritage of Indian Art,"

American Scene 6:3 (1965) published by the Thomas Gilcrease Institute of American History and Art. Well-written articles on regional styles include Arthur Silberman, "Early Kiowa Art," *Oklahoma Today* 23:1 (Winter 1972–73); and John Anson Warner, "Contemporary Algonkian Legend Painting," *American Indian Art Magazine* 3:3 (1978), 58–69. The growing world of graphics is explored in Margaret B. Blackman and Edwin S. Hall, Jr., "Contemporary Northwest Coast Art: Tradition and Innovation in Serigraphy," *American Indian Art Magazine* 6:3 (Summer 1981), 54–61; and John Anson Warner, "Contemporary Graphic Arts of the Northwest Coast," *Four Winds* (Autumn 1980), 22–30. For an overview see also Rennard Strickland and Jack Gregory, "Indian Art: An Appreciation of American Heritage," in *North American Indian Art* (Pensacola, Fla.: Pensacola Museum of Art, 1978).

Valuable analysis and fine illustrations are found in many exhibition catalogues and museum guides. *Native American Art at Philbrook* (Tulsa: Philbrook Art Center, 1980) and *Masterworks from the Museum of the American Indian — Heye Founda-*

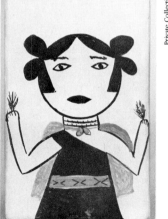

Private Collection

Private Collection

The depth, breadth, and variety of individual style can be seen by comparing Native American interpretations of the Indian woman. Moving from the left, note the varying moods and strength of the women in R. C. Gorman's *Four Spirits,* Joan Hill's *Child of the Elements,* Ruth Blalock Jones's *Woman Dancer,* Patricia Honie's *Hopi Ceramic Tile* and Bill Glass's *Cherokee Woman.*

tion (New York: Metropolitan Museum of Art, 1973) are treasure troves from important collections. Other similar works are Richard Conn, *Native American Art in the Denver Art Museum* (Seattle: Denver Art Museum and University of Washington Press, 1979); and *Fred Harvey Fine Arts Collection* (Phoenix, Ariz.: Heard Museum, 1976). A model of art scholarship with thoughtful essays and helpful maps is *American Indian Art: Form and Tradition* (New York: E. P. Dutton, 1972) produced by the Walker Art Center, the Indian Art Association, and the Minneapolis Institute of Arts. Barbara Hail has incorporated very helpful guides to design and manufacture in *Hav Kola: The Plains Indian Collection of the Haffenceffer Museum of Anthropology* (Providence, R.I.: Brown University, 1981). A valuable exhibition catalogue is Arthur Silberman, *100 Years of Native American Painting* (Oklahoma City: Oklahoma Museum of Art, 1978). Records of shows assembled by Norman Feder are *Art of the Eastern Plains Indians* (New York: Brooklyn Museum, 1964); *American Indian Art Before 1850* (Denver, Colo.: Denver Art Museum, 1965); *North American*

Indian Painting (New York: Museum of Primitive Art, 1967); and *Two Hundred Years of North American Indian Art* (New York: Praeger and Whitney Museum of American Art, 1971).

A pictorial overview of one regional variation of native art is provided in Phillip M. Holstein and Donnelley Erdman (eds.), *Enduring Visions: 1000 Years of Southwestern Art* (Aspen, Colo.: Aspen Center for the Visual Arts, 1979). Two significant and well-illustrated German studies are: Horst Hartmana, *Die Plains — und Prarieindianer Nordamerikas* (Berlin: Museum für Volkerkunde, 1973); and Wolfgang Haberland, *Donnervogel und Rabunal* (Hamburg: Hamburgisches Museum fur Volkenkunde, 1979). Much of the best literature on northwest, Canadian, and Alaskan art is in gallery publications such as *Contemporary Indian Art: The Trail from the Past to the Future* (Peterborough, Ontario: Trent University Press, 1977); *Contemporary Native Art of Canada: The Woodland Indian* (Toronto; Royal Ontario Museum, 1976); *Musée de l'Homme: Masterpieces of Indian and Eskimo Art from Canada* (Paris: Société des Amis du Musée de l'Homme,

1969); Henry B. Collins, Frederica de Laguna, Edmund Carpenter, and Peter Stone, *The Far North: 2000 Years of American and Eskimo Art* (Washington, D.C.: National Gallery of Art, 1973); Olive Patricia Dickason, *Indian Arts in Canada* (Ottawa, Toronto: Department of Indian Affairs and Northern Development, 1972); and Ted J. Brasser, *"Bo'jou, Neejee!" Profiles of Canadian Indian Art* (Ottawa, Toronto: National Museum of Man and National Museums of Canada, 1976). Other exhibitions and catalogues which highlight institutional collections or specialized topical areas are Fritz Scholder, *Indian Kitsch: The Use and Misuse of Indian Image* (Flagstaff, Ariz.: Northland Press and Heard Museum, 1979); Richard Pohrt, *The American Indian: The American Flag* (Flint, Mich.: Flint Institute of Arts, 1975); Harold Peterson, *I Wear the Morning Star: An Exhibition of American Indian Ghost Dance Objects* (Minneapolis, Minneapolis Institute of Arts, 1975); and Richard Conn, *Robes of White Shell and Sunrise: Personal Decorative Arts of the Native American* (Denver, Colo.: Denver Art Museum, 1974).

Joseph Mora's early photographs of the Hopi (1904-06) capture the spirit of Hopi religious ceremonials as living cultural experiences. The white-faced Alo Manas are shown during the *Niman* ceremony holding notched sticks and animal bones with which they produce a rhythmic sound. At right, elements of traditional Northwest Coast design and style survive in this contemporary example of the mask maker's art.

University of Tulsa/John R. Wilson

Private Collection

A particularly intriguing integration of the Thomas Gilcrease Institute's Indian collection with a running narrative of American history is found in "Story of a Hemisphere," *American Scene,* Special Issue 17 (1976). A sense of regional, geographic, and culture-area influences on native art emerges from the Bi-Centennial Council of Great Britain exhibition, organized with the support of the British-American Association. The catalogue, published as Ralph T. Coe, *Sacred Circles: Two Thousand Years of North American Indian Art* (London: Arts Council of Great Britain, 1976), is unique in illustrating important items from European collections. The most successful integration of Indian art into a general history was achieved by the Reader's Digest Association in James A. Maxwell (ed.), *America's Fascinating Indian Heritage* (Pleasantville, N.Y.: Reader's Digest Association, 1978).

Students of the history of modernism are familiar with the depth of contemporary artists' interest in primitivism.[5] For example, the influences of works like African and American Indian masks can be seen in contemporary painters and sculptors from Picasso to Moore to Pollock.[6] Theodore Roosevelt, in reviewing the influential Armory Show of 1913, recognized the kinship of Indian symbolism to modern abstraction but asserted, "There is more fine abstract design in one of my Navajo rugs than in all these modern paintings."[7] It is ironic that the moderns forced us to understand the sophistication of the primitive and to appreciate differing levels of reality.

As Native American painters are increasingly influenced by modern non-Indian painters who were in turn influenced by the primitive, we have a classic example of double cross-fertilization. It is like a mirror reflecting back upon a mirror. The image goes on and on and on. The contemporary Indian mirrors the cubist, who mirrors the carver of primitive masks, who mirrors the native world view. Thus the modern Indian artist lives in a house of mirrors. He stands face to face with both ethnic and artistic images. For example, white society has created an image of the Indian, a racial stereotype which is but a mirror of the problems of white society itself. Likewise there is the Indian society's own image of itself and of white society. Images endlessly reflect back into themselves.

On this theoretical and philosophical level a number of studies explore Indian image, primitive art, and the relationship of art to society. Art plays a different role in the Indian's society from that in the Anglo world. There is no more vivid or human portrait of the integration of art and life than Alice Marriott's story of the changing world of the Kiowas, *The Ten Grandmothers* (Norman: University of Oklahoma Press, 1945). To understand the Indian image from the perspective of the white man and his art, literature, and culture, read Ellwood Parry, *The Image of the Indian and the Black Man in American Art, 1590–1900* (New York: George Braziller, 1974); Rena N. Coen, *The Red Man in Art* (Minneapolis, Minn.: Lerner Publications, 1972); Robert F. Berkhofer, *The White Man's Indian: Images of the American Indian from Columbus to the Present* (New York: Alfred A. Knopf, 1978); and Leslie A. Fiedler, *The Return of the Vanishing American* (New York: Stein and Day, 1968). A brief exploration of visual images can be found in Phil Lucas,

Virginia Stroud's strikingly modern watercolor *Cherokee Curing* is rooted in traditional Cherokee ceremonial arts utilizing fire, masks, shell shakers, and the number seven. The strong cubist influence in Oscar Howe's *Victory Dance* (center) conveys a prevalent Indian theme with a remarkably native feeling of tempo. From prehistoric pottery to modern painting, Native American artists have sought the symbolic essence of things. The ribbon appliqué work in this photo (right) of turn-of-the-century Indians illustrates this historic use of abstraction.

"Images of Indians," *Four Winds* (Autumn 1980), 68–77.

The seminal work on native and traditional art, the sounding shot in the continuing debate, is the Franz Boas classic, *Primitive Art* (New York: Dover, 1955). The standard work on native influences on contemporary Western art is Robert Goldwater, *Primitivism in Modern Art* (New York: Random House, Vintage Books, rev. ed., 1967). A valuable compilation of essays is Carol F. Jopling's *Art and Aesthetics in Primitive Societies: A Critical Anthology* (New York: E. P. Dutton, 1971). Other works which provide insights are T. G. E. Powell, *Prehistoric Art* (New York: Praeger, 1966); Roger Cardinal, *Primitive Painters* (New York: St. Martin's Press, 1979); and Andreas Lammel, *Prehistoric and Primitive Man* (New York: McGraw-Hill, 1966). The Rockefeller Collection of Primitive Art is the subject of a stunning book providing an opportunity to compare works of art across continents and cultures. That book is Douglas Newton, *Masterpieces of Primitive Art* (New York: Alfred A. Knopf, 1978).

Patrons of Native American art often view Indian painting as an evolutionary process; they see a family tree that runs from primitive to modern, from traditional to abstract. There is remarkable continuity in theme and style. But the process comes full circle, returning to many of the ancient forms and ideas. The ancestral painter of the abstracted parrot or turkey on a Mimbres pot or the artist who drew the hands on a Hopi Sikyatki bowl was doing exactly what Linda Lomaheftawa is doing in *Night Parrot #2* and *Cosmic Hands*. The primitive and the modern are parts of the same artistic tradition. While Indian art has multiple artists and thereby multiple intentions, the Indian cultural world view is the essence of Native American painting, whether the style is traditionalism or individualism. All speak to an Indian experience in an Indian idiom.

The ledger-book creator of battlefield Indian riders was no more trying to reproduce the Battle of Little Bighorn photographically than Randy Lee White in *Custer's Last Stand Revised* is seeking to create realistic 1928 Chevrolets or Texaco gas-station attendants. These artists are "reductionists," painting symbols that go to the essence of being.

Indian art may seem clumsy and ineffectual if the viewer believes the native artist is trying to paint a real horse in the style of a European salon painter. Indian art is highly sophisticated abstraction when one understands why the painter draws transparent horses stacked horse upon horse. It is not childish gibberish but a language of philosophical metaphor whereby the artist communicates at a different level of reality. The work of art explains itself to those who understand the symbols and the world view they embody. An increasingly secular Western society whose art is a nihilistic statement of the degeneration of values has difficulty understanding the art of a deeply religious society whose art is an affirmation of an ongoing and shared consensus of values.

The history of traditional Indian painting is most often traced to the late nineteenth century. The most detailed record of early ledger painting within a single tribe is Peter John Powell's two-volume study *People of the Sacred Mountain: A History of the Northern Cheyenne Chiefs and Warrior Societies, 1830–1879* (New York: Harper & Row,

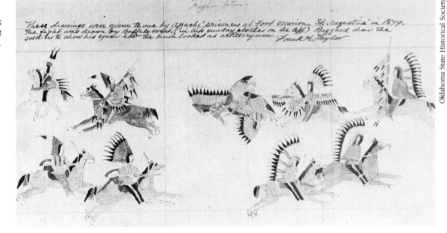

Apache prisoners Buffalo Meat and Buzzard executed this ledger book painting at Fort Marion in 1879. Such paintings provide an important transition from native art on buffalo hide to art on paper and canvas.

1981). The broader evolutionary nature of the world of Plains painting can be explored in the following: John C. Ewers, *Plains Indian Painting: A Description of an Aboriginal Art* (Stanford, Calif.: Stanford University Press, 1938); Indian Arts and Crafts Board, *Contemporary Sioux Painting* (Rapid City, S.Dak.: Tipi Shop, 1970); and Myles Libhart, *Contemporary Southern Plains Indian Painting* (Anadarko: Oklahoma Indian Arts and Crafts Cooperative, 1972). Ledger-book and hide art have attracted more serious and popular interpretation than any other phase of Indian painting. Representative works of early artists are found in the following: Amos Bad Heart Bull, *A Pictographic History of the Oglala Sioux,* ed. Helen H. Blish (Lincoln: University of Nebraska Press, 1967); Burton Supree with Ann Ross, *Bear's Heart: Scenes from the Life of a Cheyenne Artist of One Hundred Years Ago with Pictures by Himself* (Philadelphia: J. B. Lippincott, 1977); E. Adamson Hoebel and Karen Peterson, *A Cheyenne Sketchbook by Cohoe* (Norman: University of Oklahoma Press, 1964); Dorothy Dunn, *1877: Plains Indian Sketch Book of Zo-Tom and Howling Wolf* (Flagstaff, Ariz.: Northland Press, 1969); Karen Peterson, *Howling Wolf* (Palo Alto, Calif.: American West, 1968); and Karen Peterson, *Plains Indian Art from Fort Marion* (Norman: University of Oklahoma Press, 1971).

Tents and rawhide carriers are the subjects of three extensively illustrated studies. John Ewers's *Murals in the Round: Painted Tipis of the Kiowa and Kiowa-Apache Indians* (Washington, D.C.: Renwick Gallery, Smithsonian Institution Press, 1978) may be the finest visual presentation of the meaning of symbols in Indian life ever published. An effort to recapture this art is reported in Myles Libhart and Rosemary Ellison (eds.), *Painted Tipis by Contemporary Plains Indian Artists* (Anadarko: Oklahoma Indian Arts and Crafts Center, 1973). Mabel Morrow's *Indian Rawhide: An American Folk Art* (Norman: University of Oklahoma Press, 1975) is detailed and colorful. An earlier but important monograph is James Mooney, *Calendar History of the Kiowa Indians,* reissued with a new introduction by John C. Ewers (Washington, D.C.: Smithsonian Institution Press, 1979). An important extension of the pictographic tradition by Native American artists under the WPA is explored in Nicholas Calcagno's *New Deal Murals in Oklahoma* (Oklahoma City: Oklahoma Humanities Committee, 1976). The personal experience of one Kiowa mural painter is told in Alice Marriott, *The Ten Grandmothers* (Norman: University of Oklahoma Press, 1945).

Students of Indian painting interested in twentieth-century trends and popular taste can follow this in a half dozen or so statements and exhibition catalogues. Excellent individual essays and illustrations are found in the guide to a pioneer New York show, John Sloan and Oliver LaFarge's two-volume *Introduction to American Indian Art* (New York: Exposition of Indian Tribal Arts, 1931). The works of the early studio painters are represented in Addison Gallery of American Art, *Paintings and Pottery by Students of the Santa Fe School* (Andover, Mass.: Phillips Academy, 1934). An important effort to view Indian aesthetic expression in an art context is Frederick H. Douglas and Rene d'Harnoncourt, *Indian Art of the United States* (New York: Museum of

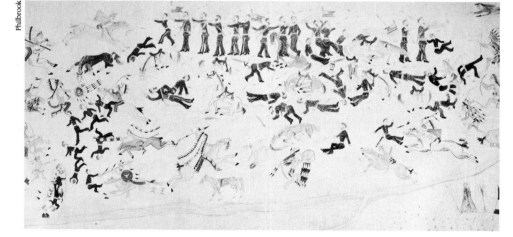

Philbrook

Paintings such as this Cheyenne recounting of the Battle of the Little Bighorn are important not only as artistic masterpieces but also as historic documentation of the Native American's view of the frontier experience. This work on muslin has been read and interpreted by contemporary Cheyenne historians who have identified individuals, clans, and terrain. Shown at left is a detail of the painting, which is thirty-five inches in height and 174 inches in width. The work is a gift of Mrs. Jacqueline Zink.

Modern Art, 1941). A significant postwar showing is reflected in Dorothy Dunn, *Contemporary American Indian Painting* (Washington, D.C.: National Gallery of Art, 1948). The impact of the Bacone College Art Department on Indian painting is demonstrated by *Bacone College Centennial Touring Art Exhibit* (Muskogee, Okla.: Bacone College, 1980). The influential Rockefeller Foundation's University of Arizona conference on the future of Indian art is reviewed in Frederick J. Dockstader (ed.), *Directions in Indian Art* (Tucson: University of Arizona Press, 1959). Publications which show the theory and practice of the Institute of American Indian Art are Lloyd Kiva New, *Future Directions in Native American Art* (Santa Fe, N.Mex.: Institute of American Indian Art, 1972) and the catalogue *Alumni Exhibition of the Institute of American Indian Arts* (Fort Worth, Texas: Amon Carter Museum, 1973).

As these exhibitions show, Indian art has moved from the anonymous artist to the identified painter, carver, potter, and weaver. There has naturally been an increased emphasis upon personal achievement

and the life, career, and artistic motivation of the individual artist. The Indian's vision, what the artist thinks he is doing, is crucial to an understanding and appreciation of Indian painting. Jane Katz has drawn together interviews with twenty contemporary Indians in *This Song Remembers: Self-Portraits of Native Americans in the Arts* (Boston: Houghton Mifflin, 1980). Another, earlier effort is John R. Milton, *The American Indian Speaks* (Vermillion: University of South Dakota Press, 1969). The testimony of these men and women in the visual arts is particularly insightful. A marvelously illustrated photographic review of the creative process among Indians of the Northwest Coast is found in Ulli Steltzer, *Indian Artists at Work* (Seattle: University of Washington Press, 1976). The same sense of the creative spirit of selected southeastern Indians emerges in Bert Seabourn's *The Master Artists of the Five Civilized Tribes* (Oklahoma City: Private printing, 1978).

The most revealing and touching account of an Indian painter is Carl Sweezy's autobiographical statement in Althea Bass, *The Arapaho Way: A*

Memoir of an Indian Boy (New York: Clarkson N. Potter, 1966). An equally moving portrait is Allen Sapp, John Anson Warner, and Theda Bradshaw, *A Cree Life: The Art of Allen Sapp* (Seattle: University of Washington Press, 1979). Pueblo revival painting is evoked by the narrative and drawings in Fred Kabotie and Bill Belknap, *Fred Kabotie, Hopi Indian Artist: An Autobiography* (Flagstaff: Museum of Northern Arizona, 1977). Acee Blue Eagle provides insight into his own motivations and those of other artists in *Oklahoma Indian Painting-Poetry* (Tulsa: Acorn Publishing Co., 1959). Scott Momaday invites us into the world of his painter father, Al Momaday, in the autobiographical *Names: A Memoir* (New York: Harper & Row, 1976). The wood sculptor Willard Stone reveals the workings of his creative imagination in *Willard Stone: Wood Sculptor* (Muskogee, Okla.: Five Civilized Tribes, 1968).

The classic Indian artistic biography is Alice Marriott's *María: The Potter of San Ildefonso* (Norman: University of Oklahoma Press, 1948). This study has particular relevance to Indian painting because it is also the story of Julian Martínez. There are at least a

Indian exhibitions and painting competitions influenced the development of Indian art and the emerging careers of individual artists, particularly in the period immediately before and after the Second World War. The photograph at left was taken at Philbrook Art Center's 1958 Indian Annual.

The emergence of the named Indian artist is illustrated by this Apache gift basket with the name of the weaver in the design. Over the past century the movement in Indian art has been from anonymous craftspersons to identifiable artisans.

Philbrook

Private Collection

dozen biographies of María with varying emphases upon her husband and his work as a painter. The most beautiful are Susan Peterson's *The Living Tradition of María Martínez* (Tokyo and New York: Kodansha International, 1977); and Richard L. Spivey's *María* (Flagstaff, Ariz.: Northland Press, 1979). These should be read with the Maxwell Museum's *Seven Families in Pueblo Pottery* (Albuquerque: University of New Mexico Press, 1974) for an understanding of Pueblo potters and their relationships to Pueblo painters.

Many recent studies of individual Indian artists focus upon their painting with particularly exquisite examples reproduced in color. The two major works on Fritz Scholder are Clinton Adams, *Fritz Scholder Lithographs* (Boston: New York Graphics Society, 1975); and Fritz Scholder, *Scholder/Indians* (Flagstaff, Ariz.: Northland Press, 1972). Two books about R. C. Gorman are particularly handsome. These are Doris B. Montham, *R. C. Gorman: The Lithographs* (Flagstaff, Ariz.: Northland Press, 1978); and Tricia Hurst, *R. C. Gorman: The Posters* (Flagstaff, Ariz.: Northland Press, 1980). A wonderfully

gentle and exquisitely printed book is *The Peyote Ritual: Visions and Descriptions of Monroe Tsa Toke* (San Francisco: Grabhorn Press, 1957), with a very personal introduction by Susan Peters entitled "The Spirit of a Kiowa Artist." A prize-winning example of the bookmaker's craft is Lister Sinclair and Jack Pollock, *The Art of Norval Morrisseau* (Toronto, Ontario: Methuen, 1979). The wonderfully bizarre story of a Cherokee family who became Northwest Coast craftspersons is told in Randolph Falk, *Leloos-ka* (Millbrea, Calif.: Celestial Arts, 1976).

A lovingly written and lavishly illustrated recollection about a young artist who died just as his talent was maturing is found in Peggy Tiger and Molly Babcock, *The Art and Life of Jerome Tiger: War to Peace, Death to Life* (Norman: University of Oklahoma Press, 1980). Jerome Tiger's artistic evolution is seen in the sketches in E. L. Gilmore, *The Tiger Legacy* (Tulsa: Private printing, 1968). Five books about Indian artists designed primarily for young people offer overviews of tribal culture as an influence in the works of painters and sculptors. These volumes are Mary Carroll Nelson, *Pablita*

Velarde (Minneapolis, Minn.: Dillon Press, 1971); Dragos D. Kostich, *George Morrison* (Minneapolis, Minn.: Dillon Press, 1976); Neva Williams, *Patrick Des Jarlait: The Story of an Indian Artist* (Minneapolis, Minn.: Lerner Publications Co., 1975); John R. Milton, *Oscar Howe* (Minneapolis: Dillon Press, 1976); and Mary Carroll Nelson, *Michael Naranjo: The Story of an American Indian* (Minneapolis, Minn.: Dillon Press, 1975). A recent work on a popular Oklahoma painter is Dick Fontain, *Cherokee Artist Bert D. Seaborn* (Oklahoma City: Prairie Hawk Publications, 1979). Two thoughtful works on graphic artists of Alaska and the Northwest are Hillary Stewart, *Robert Davidson: Master Printmaker* (Seattle: University of Washington Press, 1979); and Dorothy Eber, *Pitseolak: Pictures Out of My Life* (Seattle: University of Washington Press, 1979). The most beautiful, disturbing, and exciting work on an individual artist may be the posthumous *T. C. Cannon: A Memorial Exhibit* (New York: Aberbach Fine Art, 1980). The juxtaposition of Cannon's poetry and his paintings creates a poignant testimonial.

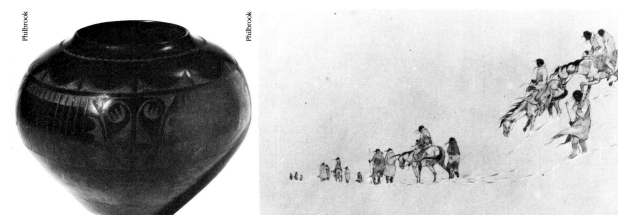

Philbrook

Philbrook

Maria Martinez, whose pot is shown at left, was the most famous native artist of this century and her works were among the first to be collected on the strength of an Indian artist's name as well as artistic merit. Jerome Tiger, a young Creek who died before he had matured as a painter, is perhaps more important for his impact on other painters than for his own meticulously crafted and handsomely colored works. At right, his *The Endless Trail*.

The relationship of Native American art to tribal life and legend is highlighted in a series of books illustrated by Indians. The paintings and drawings in the volumes represent some of the finest work of these artists. The best is Pablita Velarde's *Old Father: The Storyteller* (Globe, Ariz.: Dale Stuart King, 1960), in which the artist paints the stories she tells. Work by Acoma artist Wolf Robe Hunt illustrates Helen Rushmore's *The Dancing Horses of Acoma* (New York: World Publishing Co., 1963). Very early works of Beatien Yazz (Jimmy Todd) are central to the story of Alberta Pierson Hannum's *Spin a Silver Dollar* (New York: Viking Press, 1946). The Indian Spirit Tale Series compiled by Jack Gregory and Rennard Strickland brings together artist and tribal story. These books include *Cherokee Spirit Tales,* illustrated by Willard Stone (Muskogee, Okla.: Indian Heritage Association, 1969); *Creek-Seminole Spirit Tales,* illustrated by Fred Beaver (Muskogee, Okla.: Indian Heritage Association, 1971); *Choctaw Spirit Tales,* illustrated by C. Terry Saul (Muskogee, Okla.: Indian Heritage Association, 1972); and *American Indian Spirit Tales,* illustrated by Howard

Collins (Muskogee, Okla.: Indian Heritage Association, 1974). Walter Richard West provided full-color paintings for the two volumes of Johanna R. M. Lyback's *Indian Legends* (Chicago: Lyons and Carnahan, 1963). The ultimate interpretation of the so-called Bambi style of Indian painting is found in Acee Blue Eagle's illustrated story *Echogee: The Little Blue Deer* (Tulsa: Private printing, 1971).

The works of Indian painters also appear in anthropological and ethnographic studies. There is an old tradition of paintings of Katcina figures and ceremonial designs executed by Hopi artists. See, for examples, Barton Wright, *Kachinas: A Hopi Artist's Documentary* (Flagstaff, Ariz.: Northland Press and Heard Museum, 1973) and the classic Jesse Walter Fewkes, *Hopi Katcinas Drawn by Native Artists* (Glorieta, N.Mex.: Rio Grande Press; reissued 1969). One of the most beautiful books published in America is Fred Kabotie's *Designs from the Ancient Membrenos with a Hopi Interpretation* (San Francisco: Grabhorn Press, 1949). Kabotie's narrative is as rich as Grabhorn's bookmaking art. Examples of native carving are integrated with tribal

legends in Joseph H. Wherry, *Indian Masks and Myths of the West* (New York: Funk and Wagnalls, 1969). An interesting series of fifteen drawings in white tempera on brown posterboard were done by Jerome Tiger for Alice Marriott's *Kiowa Years: A Study in Cultural Impact* (New York: Macmillan, 1968).

These tribally related books are essential because art must be understood in a cultural context. We know that one both naturally absorbs and is formally taught the values and unstated assumptions of the culture in which he grows up. For the American Indian many values are deeply religious and tied to mystical experiences. In Western culture a personal symbol or vision or song seems on the surface to have less value as property than such incorporeal assets have in Indian culture. Yet Coca Cola fights to preserve a trademark, and radio stations pay royalty when they play "Happy Birthday." One who understands the mystical and spiritual nature of Indian society sees Indian art more clearly. Frank LaPena's *Deer Rattle–Deer Dancer* and Acee Blue Eagle's *The Deer Spirit* impart a different vision to an Indian

Carved wooden Katcinas have become so popular that many collectors may not realize that they represent real dancers who, in turn, represent spirits central to Hopi life. Joseph Mora's photograph of Heheya Aumutaka or Tu-uqti (shown in detail) records the July *Niman,* the 16-day farewell ceremonial which is the last Katcina event of the year. At right, the Creek artist Acee Blue Eagle's *The Deer Spirit* conveys a sense of the power of the supernatural through the small deer ghost figure which dominates the painting.

University of Tulsa/John R. Wilson

University of Tulsa

who knows the role of ghosts from that imparted to someone with a literalistic or mathematical outlook. Societies, of course, borrow symbols, and some symbols become almost universal — as in Woody Big Bow's traditional portrait of an Indian woman, whose middle finger is extended in the air to reflect displeasure.

Many of the jokes of a culture are difficult to transfer or translate. Despite white stereotypes of stoic and frozen-faced Indians, humor is at the heart of much Indian life, culture, and art. In part, that is because the only way to survive in the face of much of what white society has done to the Indian is to laugh — both at the white man and at the irony of one's own plight. Early Northwest Coast carvers with their wonderfully pompous argillite sculptures of white sailors and ship captains were doing what Fritz Scholder, Bob Haozous, T. C. Cannon, and Grey Cohoe have done. But Indian humor in art is not simply defensive; Indian art is more than a combat force. The movement away from the painter's openly political posturing of the 1960s and early 1970s is almost complete. Today the Indian's

polemical statements are deeply integrated into the creative process and the finished work. The colors and shadows of Grey Cohoe's *Tocito Waits for Boarding School Bus* speak more eloquently of the Indian educational experience than slogan-painted posters and drawings. Coyote in Harry Fonseca's world is a mirror in which the painter gives the trickster animal human frailty. Thus he does what the Indian storyteller has always done: he makes us laugh at ourselves.

It is impossible to understand painting and sculpture without a broader understanding of the imagery of all native arts and crafts. There is no published iconography for designs and themes in Indian painting. Discussions of motifs from pottery, masks, basketry, Katcina, jewelry, weaving, and other arts are basic to easel art and sculpture. The literature of Indian craft arts is so large that only a few books which contribute to an understanding of theme and design element are considered here. A beginner's pictorial introduction to a variety of related objects is Robert Ashton and Jazefa Stuart, *Images of American Indian Art* (New York: Walker

and Co., 1977). Strong analysis and carefully selected illustrations make Christian F. Feest's *Native Arts of North America* (New York: Oxford University Press, 1980) a convenient and sophisticated guide. The Bureau of Indian Affairs highlights design elements in their catalogue *One with the Earth* (Santa Fe, N.Mex.: Institute of American Indian Arts, 1976).

Regional and geographic styles and designs have significant influence on contemporary painting and sculpture. No work quite matches the sophisticated interpretation of Bill Holm's pioneering evaluations in *Northwest Coast Indian Art: An Analysis of Form* (Seattle: University of Washington Press, 1965). The popular and scholarly literature on the Northwest and Canada should serve as a model for other area studies. A number of important catalogues have already been cited as examples of visual and analytical integration. Northwest Coast carving and Meso-American pre-Columbian ceramics have long been recognized as fine art, while until quite recently most other Indian art was treated as ethnographic curiosities. For this reason there is a particularly

This Sioux beaded vest on hide foundation is covered front and back with elaborate decorations including American flags and crosses. Indian artists borrowed patriotic and religious images from white culture just as they had borrowed the horse itself. At right is a Shoshone painted elk hide which records the Sun Dance, the buffalo hunt, and camp life. The hide is a gift of Mrs. Elizabeth Cole Butler.

rich body of art history and aesthetic interpretation of Northwest Coast materials. Publications worth reviewing include Wilson Duff, Bill Holm, and Bill Reid, *Arts of the Raven: Masterworks of the Northwest Coast Indian* (Vancouver, British Columbia: Vancouver Art Gallery, 1967); Robert Bruce Inverarity, *Art of the Northwest Coast Indians* (Berkeley: University of California Press, 1950, 1967); Erna Siebert and Werner Forman, *North American Indian Art* (New York: Tudor, 1967); Erna Gunther, *Art in the Life of the Northwest Indians* (Seattle, Wash.: Portland Art Museum, Rasmussen Collection, 1966); Allen Wardell, *Objects of Bright Pride: Northwest Coast Indian Art from the American Museum of Natural History* (New York: Center for Inter-American Relations and American Federation of Arts, 1978); and Hillary Stewart, *Looking at Indian Art of the Northwest Coast* (Seattle: University of Washington Press, 1979). Other specialized but highly regarded monographs and surveys are Audrey Hawthorn, *Kwakiutl Art* (Seattle: University of Washington Press, 1979); Robin Cohen, *Quill Work by Native Peoples in Canada* (Toronto, Ontario: Royal Ontario Museums, 1977); Robin Cohen, *Contemporary Native Arts of Canada: The Western Subartic* (Toronto, Ontario: Royal Ontario Museums, 1977); A. McFayden Clark (ed.), *The Athapaskans: Strangers of the North* (Ottawa, Ontario: National Museum of Man, 1974); Marion Johnson Mochon, *Masks of the Northwest Coast* (Milwaukee, Wis.: Milwaukee Public Museums Publication in Primitive Art, 1966); and Peter L. McNair, Alan Hoover, and Kevin Neary, *The Legacy: Continuing Traditions of Canadian Northwest Coast Indian Art* (Victoria, British Columbia: British Columbia Provincial Museum, 1980).

For Indians of the Southeast and their historic tradition, see Emma L. Fundaburk, *Sun Circles and Human Hands: The Southeastern Indians, Arts, and Industries* (Luverne, Ala.: Fundaburk Publishers, 1957); and Phillip Phillips and James A. Brown, *Pre-Columbian Shell Engravings from the Craig Mound at Spiro, Oklahoma* (Cambridge, Mass.: Peabody Museum Press, Harvard University, 1978). For yet another cultural area consult the excellent contribution of the Flint Institute of Arts, *Art of the Great Lakes Indians* (Flint, Mich.: Flint Institute of Arts, 1973). Companion volumes by Clara Lee Tanner suggest the continuity of a regional tradition. These are *Southwest Indian Craft Arts* (Tucson: University of Arizona Press, 1968) and *Prehistoric Southwestern Craft Arts* (Tucson: University of Arizona Press, 1976). The photographer Ray Manley designed his *Southwestern Indian Arts and Crafts* (Tucson: Ray Manley Photography, 1975) as a pictorial testimonial to native artists but with brief and valuable commentaries by recognized authorities.

Kiva paintings, pottery decoration, and ceremonial figures of the Southwest provide excellent comparative sources for the student of Indian painting. Fred Kabotie's *Designs from the Ancient Membreños with a Hopi Interpretation* (San Francisco: Grabhorn Press, 1949) is an example of a contemporary Indian artist working with prehistoric designs. The definitive work on more recent pottery is Edwin L. Wade and Lea S. McChesney, *Historic Hopi Ceramics: The Thomas V. Keam Collection of the Peabody Museum of Archaeology and Ethnology, Harvard University* (Cambridge, Mass.: Peabody

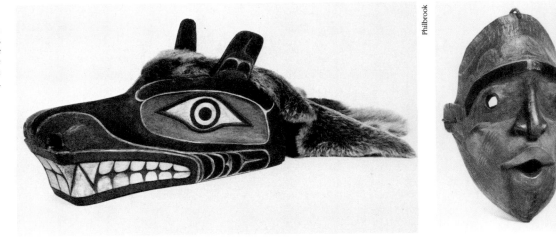

A Kwakiutl bear mask, c. 1900, of carved and painted wood, from Southern British Columbia, and a powerful Bella Coola dance mask, c. 1860, also from British Columbia. Traditional Native American art—particularly Northwest Coast masks—influenced the painting and sculpture of European and American modernists from Picasso to Pollock. Both masks are gifts of Mrs. Elizabeth Cole Butler.

Philbrook

Philbrook

Museum Press and Harvard University Press, 1981). Other books with a strong design focus are Kenneth M. Chapman, *The Pottery of San Ildefonso* supplementary text by Francis H. Harlow (Albuquerque, N.Mex.: School of American Research Monograph Series and University of New Mexico Press, 1970); Jesse Walter Fewkes, *Designs on Prehistoric Hopi Pottery* (New York: Dover Publications, 1973); Dorothy Smith Sides, *Decorative Art of the Southwestern Indians* (New York: Dover Publications, 1961); and Victor Michael Giammattei and Nanci Greer Reichert, *Art of a Vanished Race: The Mimbres Classic Black-on-White* (Woodland, Calif.: Dillon-Tyler, Publishers, 1975). Pottery is portrayed in a number of lavishly illustrated works, including Robert H. Lister and Florence C Lister, *Anasazi Pottery* (Albuquerque: University of New Mexico Press, 1978); J. J. Brody, *Mimbres Painted Pottery* (Albuquerque: University of New Mexico Press, 1977); Larry Frank and Francis H. Harlow, *Historic Pottery of the Pueblo Indians* (Boston: New York Graphic Society, 1974); Francis H. Harlow, *Modern Pueblo Pottery* (Flagstaff, Ariz.: Northland Press,

1977); and Spencer Gill, *Pottery Treasures: The Splendor of Southwest Indian Art* (Portland, Oreg.: Graphic Arts Center Publishing Co., 1976). The remarkable pottery collection of one individual is described in Clark Field, *Indian Pottery of the Southwest Post Spanish Period* (Tulsa: Philbrook Art Center, 1958). Among the most readily available works on prehistoric painting are Bertha P. Dutton, *Sun Father's Way: The Kiva Murals of Kuana* (Albuquerque: University of New Mexico Press, 1963); and Frank C. Hibben, *Kiva Art of the Anasazi* (Las Vegas, N.Mex.: KC Publications, 1975). A standard treatment is Watson Smith, *Kiva Mural Decorations at Awatovi and Kawaik-a,* vol. 37, Peabody Museum Papers (Cambridge, Mass.: Peabody Museum, 1952).

Other native arts — the carving of Katcinas, the weaving of blankets, the making of sand paintings, the sculpturing of stone, the construction of buildings, the smithing of jewelry — are mirrored in Indian painting. Many of these influences are obvious. A Katcina or a platform effigy pipe is sculptural in form, and a rug has a strong design element, whether it is abstracted or realistic as in pictorial

weaving. A sampling of some of these divergent arts is provided by the following: Charlene Cerney, *Navajo Pictorial Weaving* (Albuquerque: Museum of New Mexico Foundation, 1975); Franc J. Newcomb and Gladys A. Reichard, *Sandpaintings of the Navajo Shooting Chant* (New York: Dover Publications, 1975); Vincent Scully, *Pueblo Architecture,* photographs by William Current (Fort Worth and Austin, Texas: Amon Carter Museum and University of Texas Press, 1971); Polly Schaafsma, *Indian Rock Art of the Southwest* (Albuquerque and Santa Fe: University of New Mexico Press and School of American Research, 1980); and Wilson Duff, *Images, Stone B.C.: Thirty Centuries of Northwest Coast Indian Sculpture* (Seattle: University of Washington Press, 1975).

Excellent photographs of Hopi carvings are shown in Jon T. Erickson, *Kachinas: An Evolving Hopi Art Form?* (Phoenix, Ariz.: Heard Museum, 1977); *Kachinas: The Barry Goldwater Collection at the Heard Museum* (Phoenix, Ariz.: W. A. Kruger Co. and Heard Museum, 1975); and Barton Wright, *Hopi Kachinas: The Complete Guide to Collecting Ka-*

Julian Martinez transferred simple, elegant designs from pottery to paper as did many other early Pueblo painters. Contemporary Pueblo painters continue to use symbols from pottery in many of their paintings. Carl Sweezy, the Arapahoe painter, created haunting portraits, such as *Peyote Road Man,* of the Plains Indian life into which he was born. Sweezy carefully recorded both the old and the new, particularly as they merged in the Native American Church.

china Dolls (Flagstaff, Ariz.: Northland Press, 1977). Dorothy Washburn's *Hopi Kachina: Spirit of Life* (Seattle: University of Washington Press and California Academy of Science, 1980) is a truly beautiful book. For the weaver's arts see Nancy Fox, *Pueblo Weaving and Textile Arts* (Santa Fe: Museum of New Mexico Press, 1978); Marion E. Rodee, *Southwest Weaving* (Albuquerque: University of New Mexico Press, 1977); Anthony Berlant and Mary Hunt Kahlenberg, *Walk in Beauty: The Navajo and Their Blankets* (Boston: New York Graphic Society, 1977); and Dena S. Katzenberg, *And Eagles Sweep Across the Sky: Indian Textiles of the North American West* (Baltimore, Md.: Baltimore Museum of Art, 1977). The best brief guide to the historic evolution of Indian weaving is Marian E. Rodee, *Old Navajo Rugs: Their Development from 1900 to 1940* (Albuquerque: University of New Mexico Press, 1981).

Design elements in basketry are illustrated in Allan Lobb, *Indian Baskets of the Northwest Coast* (Portland, Oreg.: Graphic Arts Center Publishing Co., 1978); and Otis T. Mason, *Aboriginal American Basketry* (Layton, Utah: Peregrine Smith; reissued

1976). A good introduction to basket styles with excellent maps is Frank W. Lamb, *Indian Baskets of North America* (Riverside, Calif.: Riverside Museum Press, 1972). A tribally focused study of a most important group of basketmakers is Marvin Cohodas, *Deigikup: Washoe Fancy Basketry* 1895–1935 (Vancouver, British Columbia: Fine Arts Gallery of University of British Columbia, 1979). For a selected view of the entire range of basketry of North American Indian tribes, see Clark Field, *The Art and the Romance of Indian Basketry* (Tulsa: Philbrook Art Center, 1957); Charles Miles and Pierre Bovis, *American Indian and Eskimo Basketry: A Key to Identification* (San Francisco: Pierre Bovis, 1969); George Wharton, *Indian Basketry* (New York: Dover Publications, 1972); and Charles E. Roazire, *Indian Basketry of Western North America* (Los Angeles: Brooke House, 1977). An informative view of the development of the jeweler's art is found in E. Wesley Jernigan, *Jewelry of the Prehistoric Southwest* (Albuquerque: University of New Mexico Press, 1978); Larry Frank and Millard Holbrook, *Indian Silver Jewelry of the Southwest, 1868-1930* (Boston:

New York Graphic Society, 1978); and Spencer Gill, *Turquoise Treasures: The Splendor of Southwest Indian Art* (Portland, Oreg.: Graphic Arts Center Publishing Co., 1975).

The serious student of Indian painting and sculpture will spend a great deal of time with journals, periodicals, occasional papers, and monograph series. Significant material on specialized areas of Indian art is found in university contributions, museum leaflets, and site reports. For example, the Museum of the American Indian, Heye Foundation, *Contributions* are substantial and scholarly. The two volumes of the Indian Leaflet Series, edited by Frederic H. Douglas (Denver, Colo.: Denver Art Museum, 1930–55) is indispensable when studying tribal or individual styles of the Indian arts. Another useful series, begun at the same time, is the Southwest Museum Leaflet Series on North American Indians (Los Angeles: Southwest Museum, 1930). The most important contemporary journal, *American Indian Art Magazine,* features excellent articles with beautiful illustrations on museum collections, individual Indian artists, historical develop-

This Navajo pictorial rug and Datsolalee (Louisa Keyser) basket illustrates the strong sense of proportion and design of native weavers. The 1917 Washo basket, *We Assemble to Discuss the Happy Lives of Our Ancestors,* is regarded as one of the masterpieces of Native American art.

Private Collection

Philbrook

ment of crafts, and other topics of interest to scholars and collectors. It is a first-rate effort. Two newspaper-style publications which are devoted to the commercial as well as popular aspects of Indian art are *The Indian Trader* and *Indian Art/West.*

State tourist magazines and museum publications often feature Indian art. *Arizona Highways* is the most notable. The specialized "collectors issues" on trade beads, pottery, baskets, and other crafts are now rare. *New Mexico Magazine* and *Oklahoma Today* report developments in their states' Indian-arts communities. Although articles are often promotional pieces for individual artists, there is commentary on Indian painting in regional art magazines such as *Southwestern Art, Oklahoma Art Gallery,* and *Artists of the Rockies and Golden West. Four Winds* is a new publication devoted to Native American art, literature, and history. Museum journals such as *Plateau, El Palacio,* and *American Scene* treat Indian art with respect and often in depth. A neglected source on early Indian art and artists is the Department of the Interior's New Deal era public relations organ *Indians at Work.* With

the recent proliferation of calendars some of the best reproductions of Indian art are available on calendars from businesses such as the Jim Halsey Company and from organizations like Oklahomans for Indian Opportunity. Ephemeral publications such as the Indian Arts and Crafts Board's Exhibition Guides, Philbrook Art Center's Indian Annual Exhibition catalogues, invitations to exhibitions and previews, gallery publicity for shows and sales, lithographers' announcements, and advertisements are all important sources of data on what is happening in contemporary Indian painting and sculpture.

This essay has explored the popular and introductory literature on Indian painting, sculpture, and related arts. Those interested in more specialized analysis will find a number of useful bibliographic tools and biographical aides. There is a basic bibliography in *American Indian Art: Form and Tradition* (New York: E. P. Dutton, 1972). Wolfgang Haberland's excellent *The Art of North America* (New York: Crown Publishers, 1964) includes a listing of major sources. Although in need of updating, Jeanne Snodgrass's *American Indian Painters: A*

Biographical Directory (New York: Museum of the American Indian, Heye Foundation, 1968) is a monumental work. A companion work is Doris O. Dawdy's *Annotated Bibliography of American Indian Painting* (New York: Museum of the American Indian, Heye Foundation, 1968). An earlier work by Anne D. Harding and Patricia Bolling, *Bibliography of North American Indian Art* (Washington, D.C.: Department of the Interior, Arts and Crafts Board, 1938) is available in a Krause reprint. See also Allen Wardwell and Lois Lebov, *Annotated Bibliography of Northwest Coast Indian Art* (New York: Library, Museum of Primitive Art, 1970). The sources listed in Dorothy Dunn's *American Indian Painting* (Albuquerque: University of New Mexico Press, 1968) are exhaustive with reference to newspaper and magazine treatment of Indian painting.

General Indian cultural and historical bibliographies help relate Indian art and life. A key to the Smithsonian's excellent monographs is Neil M. Judd, *The Bureau of American Ethnography: A Partial History* (Norman: University of Oklahoma Press, 1967). The standard guide to Indian social and

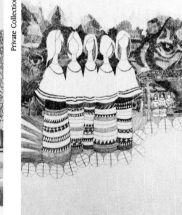

New mediums of artistic expression, particularly lithographs and etchings, have captured the interest of Native American artists. While Indian art has sustained a great continuity in subject matter, the traditional watercolor is no longer the only avenue for the Indian painter. Compare Fred Beaver's watercolor *Seminoles Bringing in Supplies,* with Ben Harjo, Jr.'s etching, *Seminole Shell Shakers.*

material cultural literature is George P. Murdock, *Ethnographic Bibliography of North America,* 3d. ed. (New Haven, Conn.: Human Relations Area Files, 1960). The tribal and subject-matter bibliographies of the Center for the History of the American Indian of the Newberry Library are exceptionally valuable, especially the exhaustive listing of almost ten thousand sources in Francis Paul Prucha, *A Bibliographic Guide to the History of Indian-White Relations in the United States* (Chicago: University of Chicago Press, 1977). Each year a bibliography is published in the *Indian Historian.*

In recent years art historians have become aware of the Native American. Their professional literature and its bibliographic tools must be consulted by anyone wishing to understand Indian painting in the broader context of the art world. The standard references and indexes to art scholarship are evaluated in a simple, straightforward manner, easily understood by the nonspecialist, in Gerd Muehsam, *Guide to Basic Information Sources in the Visual Arts* (Santa Barbara, Calif.: Jeffrey Norton Publishers, 1978). For comparative purposes the works of the non-Indian painters of Indians and Indian life must be studied. Both the American and the European traditions are rich with these images.

Scholars of Indian art, anthropology, and history have only rarely joined in the study of Native American painting and sculpture. The result has been a small body of interesting and important books, but this scholarship has an isolated focus and a narrow vision. Sound analysis of Indian art requires that disciplines join together in their work. Disturbing questions cannot be answered in the isolation of the ivory tower or in cramped museum storage space. More sophisticated understanding of Indian art demands the cooperative inquiry of patrons, collectors, traders, teachers, curators, and the artists themselves. A reasoned evaluative perspective must be established so that current Indian art controversies do not continue forever. The debate over modernism and traditionalism must be brought to an end. These are not issues which ought to consume so much of our energy. There are more serious questions worthy of debate.

Indian art should become the subject of thoughtful study by individuals of all perspectives. No longer should Indian painting and sculpture be considered in isolation, classed alternatively as ethnography or artifact or fine art or tourist curio. Only when a new perspective has been established will we begin to debate the universal aspects of Indian art. Only then will we begin to understand the perspectives of folk art, craft art, primitive art, fine art, erotic art, ethnic art, and protest art reflected in Indian painting and sculpture. Only then will we understand the divergent influences of historical events and artistic developments. Only then will we be able to relate the spiritual dimension of Indian art to broader goals and human values. Only then will native artists themselves be recognized as true national treasures.

The Indian artist is caught today in a debate over the ethnicity of his umbrella. The dilemma of the Indian painter is sharply focused in many of the works of the Kiowa-Caddo artist T. C. Cannon. The most vivid of these is his famous *Collector #5,* sometimes known as *Osage with Van Gogh.*[6] As a painting, a poster, and a woodcut, *Collector #5* has

Blackbear Bosin's *Wind Spirit* demonstrates that traditional Indian painting does not have to be static or motionless. Bosin and other painters of his generation helped bring dramatic tension to the old flat style Indian watercolors. Terry Saul's *Choctaw Scalp Dance* illustrates the achievement of ethnographically correct Indian history and culture in the context of lyrically executed and free-flowing composition.

taken on artistic significance in the Indian art debate. Abstract issues are personified by this finely dressed Osage sitting in his wicker chair between a Navajo rug and Van Gogh's *Wheatfield*. The worlds of mainstream and Indian art are here represented. In a sense, this is a modern version of Wohow's ledger drawing from Fort Marion in which a Kiowa warrior stands symbolically posed between a buffalo and a cow, between the hunt and the farm. As Karen Peterson notes in describing Wohow's masterpiece, "The Indian stands between two cultures."[7] Cannon is saying that the modern Indian makes his own culture and his own art, drawing from both worlds. The confident and smiling Osage proclaims that whatever he makes or does is uniquely and appropriately Indian.

Cannon's paintings tell us that to be a Native American is bitter as well as sweet medicine. To be an artist in any society is to be, in Thomas Wolfe's words, "life's hungry man." To be an Indian artist in white society is to be doubly cursed and twice blessed, to live in an ethnic house of mirrors. As in a carnival house, the mirrors reflect and refract, distort and deflect. The artist sees objects that endlessly reflect back into themselves. Each of us, W. H. Auden wrote, carries a mirror through life. In this mirror, Shaw observed, we see our faces; in art we see mirrored our souls. Living in a house of mirrors is a curse; creating in a house of mirrors may be a blessing. In the Indian's house of mirrors, the observant Native American artist may see around and through, glimpsing beyond the glittering surfaces and back into the deep reaches of the soul.

This essay closes with a look at one final Indian umbrella. In T. C. Cannon's painting *Grandmother Gestating Father and the Washita River Runs Ribbon-Like* the artist portrays an obviously pregnant Indian woman walking along a narrow stream.[8] The madonna's face is partly hidden under the shadow of her red umbrella, but she looks out directly into the world. This madonna speaks of the strength and resilience of Native American life and of the survival of the Indian spirit.

T. C. Cannon's *The Collector #5* or *Osage with Van Gogh* is the most widely reproduced Indian composition of the last decade. To appreciate the role of historic art and artifact in contemporary painting, compare the Osage in this turn-of-the-century photograph with T. C. Cannon's contemporary Osage in *The Collector*. At right is T.C. Cannon's wry and poignant portrayal of the resilience of the Indian family in *Grandmother Gestating Father and the Washita River Runs Ribbon-Like*.

University of Tulsa

Oklahoma State Historical Society

Aberback

NOTES

THE ETHNIC ART MARKET AND THE DILEMMA OF INNOVATIVE INDIAN ARTISTS

1. Personal Communication with Jerry Tuttle, Community Development Officer, Bureau of Indian Affairs, Albuquerque, N.Mex., 1974, and with Santo Domingo tribal officials, 1974–75.

2. Edwin L. Wade, "Economics of the Southwest Indian Art Market," Ph.D. dissertation, University of Washington, 1976; Edwin L. Wade, "History of the Southwest Indian Art Market," unpublished manuscript, School of American Research, Santa Fe, N.Mex., 1976.

3. Economic Research Associates, "Expansion Program for the Intertribal Indian Ceremonial at Gallup, New Mexico" (Washington, D.C.: Economic Development Agency, mimeographed report, 1967).

4. "The Indian as Viewed by the Indian Educational Service in 1898, from the Report of the Superintendent of Indian Schools," *Indians at Work* 3:20 (1936), 28.

5. Numerous publications have touched on the deleterious effects of commercialization of native Southwest Indian arts and crafts. See generally the following: Margery Bedinger, *Indian Silver, Navajo and Pueblo Jewelers* (Albuquerque: University of New Mexico Press, 1973); John Adair, *The Navajo and Pueblo Silversmiths* (Norman: University of Oklahoma Press, 1944); Charles Avery Amsden, *Navajo Weaving* (Santa Ana, Calif.: Five Arts Press, 1934); George Wharton James, *Indian Blankets and Their Makers* (New York: Dover Publications, 1974).

6. Henrietta K. Burton, *The Reestablishment of the Indians in Their Pueblo Life Through the Revival of Their Traditional Crafts* (New York: Teachers College, Columbia University, 1936), 22.

7. Margretta S. Dietrich, "Their Culture Survives," *Indians at Work* 3:17 (1936), 22.

8. Fritz Scholder, "Scholder on Scholder: Self-Interview," *American Indian Art* 12:2 (1976), 54.

9. Personal Communication, Bob Haozous, 1974.

10. Clipping, "IAE Releases Report on Ceremonial Protests," *Navajo Times* 13:34 (n.d.).

11. "Ceremonial at Gallup Resisted by Gallup Indians," *Wassaja* 1:2 (1973), 21.

12. Publicity Brochure, "53rd Inter-Tribal Ceremonial, Gallup, New Mexico," 1974.

13. Maggie Wilson, "Controversy Pervades Art Judging," *Arizona Republic,* November 20, 1973.

14. *Ibid.*

15. Personal Communication, Bob Haozous, 1974.

MAGIC IMAGES: THE ARTISTS AND THEIR WORK

Direct quotations appear in the sources cited for the descriptive essays on the artists. For a more general view of the literature on Native American painting and sculpture, see the essay "Beyond the Ethnic Umbrella: Learning More About Native American Painting and Sculpture." Frequent references are cited as follows:

Dunn, Dorothy, *American Indian Painting of the Southwest and Plains Area* (Albuquerque: University of New Mexico Press, 1968), cited as Dunn, *American Indian Painting.*

Highwater, Jamake, *Song from the Earth: American Indian Painting* (Boston: New York Graphic Society, 1976), cited as Highwater, *Song.*

———, *The Sweet Grass Lives On: Fifty Contemporary North American Indian Artists* (New York: Lippincott & Crowell, Publishers, 1980), cited as Highwater, *Sweet Grass.*

Institute of American Indian Arts: Alumni Exhibition (Fort Worth, Texas: Amon Carter Museum, 1973), cited as *IAIA Alumni.*

Katz, Jane B. (ed.), *This Song Remembers: Self-Portraits of Native Americans in the Arts* (Boston: Houghton Mifflin Co., 1980), cited as Katz, *Song Remembers.*

Libhart, Myles, *Contemporary Southern Plains Indian Painting* (Anadarko: Oklahoma Indian Arts and Crafts Cooperative, 1972), cited as Libhart, *Plains Painting.*

Monthan, Guy, and Doris Monthan, *Arts and Indian Individualists: The Art of Seventeen Contemporary Southwestern Artists and Craftsmen* (Flagstaff, Ariz.: Northland Press, 1975), cited as Monthan, *Indian Individualists.*

Pintura Amerindia Contemporanea (Spanish language catalogue for traveling exhibition), cited as *Pintura Amerindia.*

Silberman, Arthur (ed.), *100 Years of Native American Painting* (Oklahoma City: Oklahoma Museum of Art, 1978), cited as Silberman, *100 Years.*

Snodgrass, Jeanne O., *American Indian Painters: A Biographical Directory* (New York: Museum of the American Indian, Heye Foundation, 1968), cited as Snodgrass, *Biographical Directory.*

Tanner, Clara Lee, *Southwest Indian Painting: A Changing Art* (Tucson: University of Arizona Press, 2d. ed., 1973), cited as Tanner, *SW Indian Painting.*

1. *Bill Reid:* P. L. McNari, Alan L. Hoover, and Keavin Neary, *The Legacy: Continuing Tradition of Canadian Northwest Coast Indian Art* (Victoria, British Columbia: British Columbian Provincial Museum, 1980), 85–88; *Bill Reid Retrospective: Selected Examples of Works* (Vancouver, British Columbia: Children of the Raven Gallery, 1980); Bill Holm and William Reid, *A Dialogue on Form and Freedom: Northwest Coast Indian Art* (Houston, Texas: Rice University, 1976); Wilson Duff, Bill Holm, and Bill Reid, *Arts of the Raven: Masterworks of the Northwest Coast Indian* (Vancouver, British Columbia: Vancouver Art Gallery, 1967).

2. *Lyle Wilson:* "Northwest Renaissance" (Burnaby, British Columbia: Burnaby Art Gallery, 1980); David R. Young, "Lyle Wilson: Biography and Works" (Vancouver, British Columbia: Bent-Box Gallery, mimeographed booklet, 1980); typescript, Biographical Data File, Library, Philbrook Art Center, and Special Collections, McFarlin Library, University of Tulsa.

3. *Dempsey Bob:* "Dempsey Bob," in *Northwest Coast Indian Artists: 1979 Graphics Collection* (Toronto, Ontario: Thompson Gallery, 1979.)

4. *Donald Montileaux:* Highwater, *Sweet Grass,* 146–47: Myles Libhart and Indian Arts and Crafts Board, *Contemporary Sioux Painting* (Rapid City, S.Dak.: Tipi Shop, 1970), 78–79.

5. *Randy Lee White:* Tricia Hurst, "Randy Lee White: A Brave's New World," *New Mexico Magazine* 57:6 (June 1979), 18–19; *Pintura Amerindia,* n.p.; *North American Indian Art* (Pensacola, Fla.: Pensacola Museum of Art, 1978).

6. *Archie Blackowl:* Virginia Stroud, cited in "Artist Profile: Virginia Stroud," *Four Winds* (Winter 1980), 58–61; Blackowl interview in Highwater, *Song,* 168–72; Libhart, *Plains Painting,* 49, 67; Snodgrass, *Biographical Directory,* 23; Silberman, *100 Years,* 30; Dunn, *American Indian Painting,* 322, 356.

7. *Harrison Begay:* Letter, Harrison Begay to Philbrook Art Center, July 9, 1946, in Selected Clippings and Biographical Data File, Library, Philbrook Art Center, and Special Collections, McFarlin Library, University of Tulsa; Tanner, *SW Indian Painting,* 301–12; Snodgrass, *Biographical Directory,* 17–18; Dorothy Adlow, "Power Comes," *Christian Science Monitor,* March 25, 1959; Silberman, *100 Years,* 44–45; Dunn, *American Indian Painting,* 319–49.

8. *Virginia Stroud:* "Artist Profile: Virginia Stroud," *Four Winds* (Winter 1980), 58–61; Biographical File, Library, Philbrook Art Center and Special Collections, McFarlin Library, University of Tulsa.

9. *Gilbert Atencio:* Tanner, *SW Indian Painting,* 109–16; Snodgrass, *Biographical Directory,* 8–9; Silberman, *100 Years,* 68; Biographical Files, Library, Philbrook Art Center and Special Collections, McFarlin Library, University of Tulsa; Dunn, *American Indian Painting,* 337.

10. *Millard Dawa Lomakema:* Highwater, *Sweet Grass,* 67–70; Tanner, *SW Indian Painting,* 276–77; *Pintura Amerindia,* n.p.; Patricia Janis Broder, *Hopi Painting; The World of the Hopis* (New York: Brandywine Press, 1979).

11. *Andrew Tsinahjinnie:* Tanner, *SW Indian Painting,* 312–19; Snodgrass, *Biographical Directory,* 198–99; Silberman, *100 Years,* 98–99; Dunn, *American Indian Painting,* 273, 275–76, 280, 282, 302, 322, 349.

12. *Rance Hood:* Highwater, *Sweet Grass,* 102–104; Snodgrass, *Biographical Directory,* 80; Libhart, *Plains Painting,* 47–71.

13. *Allen Houser:* Highwater, *Sweet Grass,* 109–13: Interview in Highwater, *Song,* 144–50; Monthan, *Indian Individualists,* 77–85; Snodgrass, *Biographical Directory,* 80–81; Tanner, *SW Indian Painting,* 409–13; Silberman, *100 Years,* 62; Katz, *Song Remembers,* 101–108; Libhart, *Plains Painting,* 39, 71; *Allan Houser Limited Edition Bronzes* (Phoenix, Ariz.: The Gallery Wall, 1980); Mary Carroll Nelson, "Allan Houser: Grand Master Apache Sculptor," *American Artist* 44:460 (November 1980), 80–85; Barbara Perlman, "The Timeless Sculptures of a Plain and Happy Man," *Art News* 79:10 (December 1979), 112–14; Barbara Perlman, "Allan Houser: Songs from the Earth," *Southwest Art* 11:1 (June 1981), 50–57; Dorothy Dunn, *American Indian Painting,* 280, 282, 305, 311, 321, 320, 352.

14. *Willard Stone: Willard Stone: Wood Sculptor* (Muskogee, Okla.: Five Civilized Tribes Museum, 1968); Jack Gregory and Rennard Strickland, *Cherokee Spirit Tales,* illustrations by Willard Stone (Muskogee, Okla.: Indian Heritage Association, 1969); Biographical File, Library, Philbrook Art Center, and Special Collections, McFarlin Library, University of Tulsa.

15. *W. Richard West:* Letters and Notes, Biographical File, Library, Philbrook Art Center, and Special Collections, McFarlin Library, University of Tulsa; Snodgrass, *Biographical Directory,* 213–14; Silberman, *100 Years,* 92; Libhart, *Plains Painting,* 48, 78; "Paintings by Dick West" (Anadarko, Okla.: Southern Plains Indian Museum and Craft Center, Exhibition Guides, 1980); Dunn, *American Indian Painting,* 329, 354–55.

16. *Jerry Ingram:* Montham, *Indian Individualists,* 97–105; Snodgrass, *Biographical Directory,* 85; Biographical File, Library, Philbrook Art Center, and Special Collections, McFarlin Library, University of Tulsa.

17. *Oscar Howe:* Highwater, *Sweet Grass,* 114–18; Snodgrass, *Biographical Directory,* 81–82; Interview in Highwater, *Song,* 150–57; John R. Milton, *Oscar Howe* (Minneapolis, Minn.: Dillon Press, 1976);

Myles Libhart and Indian Arts and Crafts Board, *Contemporary Sioux Painting* (Rapid City, S.Dak.: Tipi Shop, 1970), 48–51; letters cited in Rennard Strickland, "The Changing World of Indian Painting and Philbrook Art Center," in *Native American Art at Philbrook* (Tulsa: Philbrook Art Center, 1980), 13, 24; Dunn, *American Indian Painting*, 306, 322, 325, 326, 354.

18. *Fritz Scholder:* Highwater, *Sweet Grass,* 174–78; Montham, *Indian Individualists,* 166–75; Snodgrass, *Biographical Directory,* 168; "Scholder on Scholder: A Self-Interview," *American Indian Art Magazine* 1:2 (Spring 1976), 50–55; Clinton Adams, *Fritz Scholder Lithographs* (Boston: New York Graphics Society, 1975); Fritz Scholder, *Scholder/Indians* (Flagstaff, Ariz.: Northland Press, 1972). Fritz Scholder, *Indian Kitsch: The Use and Misuse of Indian Image* (Flagstaff, Ariz.: Northland Press and Heard Museum, 1979); Rosemary Holusha, "Fritz Scholder: A Special Interview," *Art Voices/South* (September–October 1979), 24; John C. Waugh, " 'Pop Indian' Emerges from a New Renaissance," *Christian Science Monitor,* September 11, 1970, 19; Louise Durbin, "Cocktail Parties and a Cowskin in the Bathtub," *Washington Post,* March 22, 1970, H1.

19. *Frank Lapena:* Highwater, *Sweet Grass,* 132–33; *Pintura Amerindia,* n.p.

20. *Grey Cohoe: Who's Who in American Art,* 141; "Grey Cohoe," Undated, Mimeographed Biography; Drafts, Unpublished Poetry, Biographical File, Library, Philbrook Art Center, and Special Collections, McFarlin Library, University of Tulsa.

21. *Linda Lomahaftewa:* Highwater, *Sweet Grass,* 137–33; *IAIA Alumni,* 32; Mimeographed Biographical Data File, Library, Philbrook Art Center, and Special Collections, McFarlin Library, University of Tulsa.

22. *Henry Gobin:* Highwater, *Sweet Grass,* 86–88; Snodgrass, *Biographical Directory,* 63; *IAIA Alumni,* 20; *Pintura Amerindia,* n.p.

23. *Bennie Buffalo:* Highwater, *Sweet Grass,* 58–59; Myles Libhart, *Plains Painting,* 52, 68; "Paintings by Benjamin Buffalo" (Anadarko, Okla.: Southern Plains Indian Museum and Craft Center, Exhibition Guides, 1980); *IAIA Alumni,* 8.

24. *Phyllis Fife:* Highwater, *Sweet Grass,* 71–73; Snodgrass, *Biographical Directory,* 55; *IAIA Alumni,* 18.

25. *James Havard:* Janet Kutner, "James Havard," *Arts Magazine* 51:2 (October 1976), 9; Robert Yoskowitz, "James Havard," *Arts Magazine* 54:4 (December 1979); Highwater, *Sweet Grass,* 96–97.

26. *George C. Longfish:* Highwater, *Sweet Grass* 144–45; Allan M. Gordon, "Syntheses of Cultural Sources," *Art Week* 10:22 (June 16, 1979); "George C. Longfish and Mary L. O'Neal: Works on Canvas," in *Catalogue* (Berkeley, Calif.: Rolando Castellon, 1979); *Pintura Amerindia,* n.p.

27. *Jaune Quick-To-See Smith:* Highwater, *Sweet Grass,* 179–80; Katharine Smith Chafee, "Peculiar to the West," *Artspace,* September 1980, 8–12; Jan Schmitz, "Quick-To-See: Modernism in Native Tradition," *Native Arts/West* 1:5 (November 1980), 7, 9; Jamake Highwater, "Profiles of Contemporary North American Indian Artists," *Native Arts/West* 1:5 (November 1980), 6.

28. *Alvin Eli Amason:* Highwater, *Sweet Grass,* 43–44; Jamake Highwater, "Alvin Eli Amason: Profiles of Contemporary Indian Artists," *Native Arts/West* 1:2 (August 1980), 32. The story of "The Amusement of the Gods" is found in Thomas C. Oden (ed.), *Parables of Kierkegaard* (Princeton, N.J.: Princeton University Press, 1978), 125.

29. *Bob Haozous:* Monthan, *Indian Individualists,* 56–65; "Viewing Art," *Santa Fe New Mexican,* August 20, 1980; "Sculpture I" (Phoenix, Ariz.: Heard Museum, 1973); "Sculpture II" (Phoenix, Ariz.: Heard Museum, 1974); "Invitational Sculpture" (Phoenix, Ariz.: Heard Museum, 1977); Selected Biographical Data File, Library, Philbrook Art Center, and Special Collections, McFarlin Library, University of Tulsa.

30. *George Morrison:* Highwater, *Sweet Grass,* 148–52; Snodgrass, *Biographical Directory,* 125–27; "George Morrison Drawings" (Minneapolis, Minn.: Walker Art Center, 1973); Kathryn C. Johnson, "George Morrison: An American Classic," *Minneapolis Institute of Arts Bulletin* 63 (1976–77), 84–89; Katz, *Song Remembers,* 53–60; Mimeographed Biographical Data, Library, Philbrook Art Center, and Special Collections, McFarlin Library, University of Tulsa; Dragos Kostich, *George Morrison* (Minneapolis, Minn.: Dillon Press, 1976).

31. *Dan Namingha:* Highwater, *Sweet Grass,* 157–59; Mary Carroll Nelson, "Dan Namingha: The Migration of a Hopi Artist," *American Artist* (September 1979), 56–59, 90–92; Alfred Frankenstein, "A Quantum Leap in Extending Hopi Tradition," *San Francisco Chronicle,* December 19, 1978; Barbara Perlman, "Spirit of the Land," *Arizona Arts & Lifestyle* (Winter 1980), n.p.; Mary Carroll Nelson, "Dan Namingha: A Vision from Two Worlds," *Southwest Art* 11:1 (June 1981), 100–105.

32. *Norval Morrisseau:* Highwater, *Sweet Grass,* 153–56; Jamake Highwater, "Rebellion Within the Tribes," *Indian Trader* 10:5 (May 1979), 34–35, 40; C. H. Carpenter, "Artist as Trickster," *Art Magazine* 11 (November 1979), 55T; Lister Sinclair and Jack Pollock, *The Art of Norval Morrisseau* (Toronto, Ontario: Methuen, 1979).

33. *Allen Sapp:* Highwater, *Sweet Grass,* 170–73; John Anson Warner, "Allen Sapp, Cree Painter,"

American Indian Art Magazine 2:1 (Winter 1976), 40–45; Allen Sapp, John Anson Warner, and Theda Bradshaw, *A Cree Life: The Art of Allen Sapp* (Seattle: University of Washington Press, 1979); John Anson Warner, "Allen Sapp: Art as Survival: The Making of a Cree Painter," *Native Arts/West* (November 1980), 22, 25T; John Anson Warner, "Allen Sapp," *Indian Trader,* 10:4 (April 1979), 22–24.

34. *Harry Fonseca:* Highwater, *Sweet Grass,* 74–75; *Pintura Amerindia,* n.p.; Erin Younger, "Two Views of California: Maidu Paintings by Frank Day and Harry Fonseca" (Phoenix: Heard Museum, 1980); "Harry Fonseca," Leaflet from Los Llanos Gallery, Santa Fe, N.Mex., n.d.; Barbara Littlebird, "Artist Profile: Harry Fonseca," *Four Winds* (Winter 1981), 10–15.

35. *Richard Glazer Danay:* Highwater, *Sweet Grass,* 84–85; Typescript Biographical Data File, Library, Philbrook Art Center, and Special Collections, McFarlin Library, University of Tulsa.

36. *John Hoover:* Highwater, *Sweet Grass,* 106–8; Katz, *Song Remembers,* 32–37; John Hoover, interview, *American Indian Art Magazine* 3:1 (Winter 1977), 26–27; Guy and Doris Montham, "John Hoover," *American Indian Art Magazine,* 4:1 (Winter 1978), 50–55.

37. *Charles Loloma:* Montham, *Indian Individualists,* 107–15; Snodgrass, *Biographical Directory,* 103; Tanner, *SW Indian Painting,* 257; Jean Williams-Barac, "Charles Loloma," *Four Winds* (Spring 1981), 15–18; Susan Fair, "Charles Loloma," *American Indian Art Magazine* 1:1 (Autumn 1975), 54–57; "American Crafts Council Academy of Fellows Elects 11 New Members," *Craft Horizon,* 36:4 (August 1976), 6; Erin Younger, "Loloma: A Retrospective View" (Phoenix, Ariz.: Heard Museum, 1978); Dorothy Dunn, *American Indian Painting,* 316.

BEYOND THE ETHNIC UMBRELLA

1. For a case study of the effect of these controversies see Rennard Strickland, "The Changing World of Indian Painting and Philbrook Art Center," in *Native American Art at Philbrook* (Tulsa: Philbrook Art Center, 1980), 8–25.

2. H. Wayne Morgan, *New Muses: Art in American Culture, 1865-1920* (Norman: University of Oklahoma Press, 1978), 56–76.

3. "About an American School of Art," *Scribner's Monthly* 10 (July 1875), 380–81.

4. These particular umbrellas are reproduced as follows: Scholder in *Scholder/Indians* (Flagstaff, Ariz.: Northland Press, 1972), 82; Trujillo in *North American Indian Art* (Pensacola, Fla.: Pensacola Museum of Art, 1978, 42; Buffalo Meat in Rennard Strickland, *The Indians in Oklahoma* (Norman: University of Oklahoma Press, 1980), 28, and in Jamake Highwater, *Song from the Earth* (Boston: New York Graphic Society, 1975); and Cannon in *T. C. Cannon* (New York: Aberbach Fine Arts, 1980).

5. Roosevelt cited in Rennard Strickland and Jack Gregory, "Indian Art: An Appreciation of American Heritage," in *North American Indian Art* (Pensacola, Fla.: Museum of Art, 1978), 5.

6. William Benton, "T. C. Cannon: The Masked Dandy," *American Indian Art Magazine* 3:4 (Autumn 1978), 34–39.

7. Karen Peterson, *Plains Indian Art from Fort Marion* (Norman: University of Oklahoma Press, 1971), 90–91, color plate 9.

8. See generally *T. C. Cannon: Memorial Exhibition* (New York: Aberbach Fine Arts, 1980) and Edie Scott, "T. C. Cannon: 1946-1978," *Southwestern Art* 11:1 (June 1981), 76–79, picture at 79.

CATALOGUE OF THE EXHIBITION *NATIVE AMERICAN ARTS '81*

AMASON, ALVIN ELI, b. 1948
Aleut

Lay Lady, 1980
Oil, 62 x 47
Lent by Alaska Contemporary Art
Bank, Alaska State Coucil on the
Arts, Anchorage, Alaska

Papa's Duck, 1976
Mixed media, 70 x 59 x 12
Lent by Alaska Contemporary Art
Bank, Alaska State Council on the
Arts, Anchorage, Alaska

ATENCIO GILBERT, b. 1930
San Ildefonso

*San Ildefonso Pueblo Cloud
Dance,* 1977
Tempera, 27 x 22
Lent by Jim and Beth Stewart, Los
Alamos, New Mexico

BEGAY, HARRISON, b. 1917
Navajo

Squaw Dance, 1974
Casein, 29 x 23
Lent from Private Collection

BLACKOWL, ARCHIE, b. 1911
Cheyenne

Buffalo Hunt, 1980
Tempera, 29 x 23
Lent by The Galleria, Norman,
Oklahoma

Cheyenne Arapaho Family, 1980
Tempera, 18 x 31
Lent by The Galleria, Norman,
Oklahoma

BOB, DEMPSEY, b. 1948
Tlingit/Tahltan

Eagle Warrior Helmet, 1981
Alder wood, hair, 8 x 12 x 9½

Lent by the Artist, Prince Rupert,
British Columbia, Canada

Old Woman Face Mask, 1974
Alder wood, copper, horse hair,
hair, 9 x 7 x 4
Lent by the Artist, Prince Rupert,
British Columbia, Canada

BUFFALO, BENJAMIN, b. 1948
Cheyenne

Girl on a Horse, 1980
Acrylic, 36½ x 46
Lent by The Galleria, Norman,
Oklahoma

Legal Eagles, 1981
Acrylic, 40 x 44
Lent by the Artist, Rio Rancho,
New Mexico
Now owned by Sue Carter

Rodeo Queen, 1977
Acrylic, 48 x 54
Lent by Los Llanos Gallery, Santa
Fe, New Mexico

COHOE, GREY, b. 1944
Navajo

Tall Visitor at Tocito, 1981
Oil and acrylic, 60 x 48
Lent by Los Llanos Gallery, Santa
Fe, New Mexico

*Tocito Waits for Boarding School
Bus,* 1981
Oil and acrylic, 50 x 39
Lent from Private Collection

DANAY, RICHARD GLAZER, b.
1942
Mohawk

A Kiss for Ellis, 1978
Oil, enamel on wood, 8¾ x 5¼ x 2¾
Lent by the Artist, Green Bay,
Wisconsin

Deep Six, 1978
Oil, enamel, mixed media on
masonite, 18 x 8½ x 8½
Lent by the Artist, Green Bay,
Wisconsin

I'll Take Manhattan, 1978
Oil, enamel, mixed media on
wood, 10½ x 15½ x 2¾
Lent by the Artist, Green Bay,
Wisconsin

Missionary Headrest, 1978
Oil, enamel on wood, 12 x 9 x 9
Lent by the Artist, Green Bay,
Wisconsin

FIFE, PHYLLIS, b. 1948
Creek

Canvas Ghosts, 1978
Acrylic, 46 x 62
Lent by the Artist, Stilwell,
Oklahoma

The Poet in Painter's Clothing,
1977
Acrylic, 66 x 66
Lent by the Artist, Stilwell,
Oklahoma

FONSECA, HARRY, b. 1946
Maidu

Snapshot or *Wish You Were Here,
Coyote,* 1979
Acrylic and glitter, 48 x 36
Lent by Mr. and Mrs. Thomas B.
Coleman, New Orleans, Louisiana

When Coyote Leaves the Res or
*Portrait of the Artist As a Young
Coyote,* 1980
Acrylic, 48 x 36
Lent by The Heard Museum,
Indian Art Collection, Phoenix,
Arizona

GOBIN, HENRY, b. 1941
Snohomish

A Beautiful Tlingit Woman, 1981
Watercolor, 20 x 14
Lent by Los Llanos Gallery, Santa
Fe, New Mexico

Whale Dancer, 1981
Watercolor, 20 x 14
Lent by Los Llanos Gallery, Santa
Fe, New Mexico

HAOZOUS, ROBERT, b. 1943
Chiricahua Apache/Navajo

Neophyte Cowboy, 1981
Limestone, 16 x 60 x 12
Lent by Heydt-Bair Gallery, Santa
Fe, New Mexico
Now owned by Private Collection

New Mexico Landscape #13, 1979
Slate, 72 x 36 x 2
Lent by the Artist, Santa Fe, New
Mexico

HAVARD, JAMES, b. 1937
Choctaw/Chippewa

Dusty Dress, 1977
Acrylic, 64 x 96
Lent by Arnold and Elaine Horwitch,
Scottsdale, Arizona

Eagle Egg, 1978
Oil, 72 x 84
Lent by the Williams Companies,
Tulsa, Oklahoma

HOOD, RANCE, b. 1941
Comanche

Coup Stick Song, 1980
Tempera, 40 x 30
Lent by the Artist, Bellvue, Colorado

His Last Chance, 1980
Tempera, 40 x 32

Lent by Dallas Creek Arts,
Ridgeway, Colorado

HOOVER, JOHN, b. 1919
Aleut

Dance Staff Rattle, 1981
Red cedar, 96 x 5
Lent by the Artist, Grapeview,
Washington

Winter Loon Dance, 1977-78
Polychromed carved cedar. 97½ x 57½
Lent by Daybreak Star Arts Gallery,
Seattle, Washington. Donated by
Richard Pryor

HOUSER, ALLEN, b. 1915
Chiricahua Apache

Eagle Dancer, 1981
Black Tennessee marble, 14 x 38 x 22
Lent by The Gallery Wall,
Scottsdale, Arizona

Heading Home, 1980
Bronze, 53 x 53 x 22½
Lent by The Gallery Wall, Inc.,
Santa Fe, New Mexico

Water Bird, 1980
Bronze on marble base, 51 x 18 x 4
Lent by The Gallery Wall, Inc.,
Santa Fe, New Mexico

HOWE, OSCAR, b. 1915
Yanktonai Sioux

Head Dancer, 1967
Casein, 29½ x 21
Lent by The University of South
Dakota Gallery, Vermillion, South
Dakota

War Dancer, 1967
Casein, 30 x 22½
Lent by the University of South
Dakota Gallery, Vermillion, South
Dakota

INGRAM, JERRY, b. 1941
Choctaw

In Sacred Manner, 1981
Watercolor, 10 x 10
Lent by the Artist, Corrales, New
Mexico
Now owned by Philbrook Art
Center, Tulsa, Oklahoma

Sign of Strength, 1981
Watercolor, 7½ x 11¼
Lent by the Artist, Corrales, New
Mexico
Now owned by Philbrook Art
Center, Tulsa, Oklahoma

Winter Medicine, 1981
Watercolor, 10 x 13
Lent by the Artist, Corrales, New
Mexico
Now owned by Eugene B. Adkins

LAPENA, FRANK, b. 1937
Wintu

Deer Rattle-Deer Dancer, 1981
Acrylic, 48 x 34
Lent by the Artist, Carmichael,
California
Now owned by Private Collection

Ribbon Doll, 1980
Acrylic, 36 x 30
Lent by Mr. and Mrs. Ian McGreal,
Sacramento, California

LOLOMA, CHARLES, b. 1921
Hopi

Jewelry/Sculpture, 1970-81
Lent by the Artist, Hotevilla, Arizona
Gold Ring
Gold, lapis, 1½ x 1¼ x 1
Silver Ring
Silver, wood, 1½ x 1½ x ¾
Silver Bracelet (113)
Silver, wood inlay, 2⅜ x 3¼ x 1
Silver Cast Bracelet (115)
Silver, coral, ironwood, turquoise,
ivory, 2½ x 3¼ x 1½
Gold Bracelet (116)
Gold, ivory, woods, coral,
turquoise, 3½ x ¾ x ⅝

Silver Bracelet (117)
Silver, ironwood, mastadon ivory,
lapis, turquoise, 3 x 3 x 1

LINDA LOMAHAFTEWA, b. 1947
Hopi/Choctaw

Cosmic Hands, 1980
Acrylic, 48 x 36
Lent from Private Collection

Night Parrot #2, 1981
Acrylic, 22 x 30
Lent by the Artist, Santa Fe, New
Mexico

LOMAKEMA, MILLARD DAWA, b.
1941
Hopi

Two Horn Priest with Maiden,
1978
Acrylic, 50 x 48
Lent by Maggie Kress Gallery,
Taos, New Mexico,

Untitled, 1978
Mixed media, 34 x 34
Lent by Maggie Kress Gallery,
Taos, New Mexico

LONGFISH, GEORGE, b. 1942
Seneca/Tuscarora

*Mother Earth Comes to the Rescue
of the Brothers,* 1981
Acrylic, 86 x 96
Lent by the Artist, Davis, California

*You Can't Rollerskate in a Buffalo
Herd Even If You Have All the
Medicine,* 1979-80
Acrylic, 86 x 96
Lent by the Artist, Davis, California

MONTILEAUX, DONALD, b. 1948
Oglala Sioux

Attack, 1980
Watercolor on hide, quills, 36 x 39
Lent by The Tipi Shop, Inc., Rapid
City, South Dakota

Ceremonial Drum, 1980
Mixed media, 14 x 17
Lent by The Tipi Shop, Inc., Rapid
City, South Dakot

MORRISON, GEORGE, b. 1919
Chippewa

Landscape, 1981
Acrylic, 48 x 48
Lent by the Artist, Minneapolis,
Minnesota

MORRISSEAU, NORVAL, b. 1933
Ojibwa

The Light Is the Way, 1979
(two panels)
Acrylic, 50 x 124 each
Lent by The Pollock Gallery, Ltd.,
Toronto, Ontario, Canada

NAMINGHA, DAN, b. 1950
Hopi

Eagle Dancer, 1980
Lithograph, 26 x 39¾
Lent by The Gallery Wall, Inc.,
Scottsdale, Arizona

Mesa, 1980
Acrylic, 68 x 58
Lent by The Gallery Wall, Inc.,
Santa Fe, New Mexico

QUICK-TO-SEE-SMITH, JAUNE, b.
1940
Cree/Shoshone

Camas Series, Untitled, 1980
Pastel, 19½ x 28
Lent by Clarke-Benton Gallery,
Santa Fe, New Mexico

*Horse Constellation with Jack
Rabbit,* 1980
Monotype, 19½ x 28
Lent by Clarke-Benton Gallery,
Santa Fe, New Mexico

REID, BILL, b. 1920
Haida

Mythological Screen, 1968
Red cedar, 84 x 75 x 6

Lent by British Columbia
Provincial Museum, Victoria,
British Columbia, Canada

SAPP, ALLEN, b. 1929
Plains Cree

Holding Her Baby, 1973
Acrylic, 24 x 36
Lent from Private Collection

Will Be Home Soon, 1979
Acrylic, 24 x 30
Lent from Private Collection

SCHOLDER, FRITZ, b. 1937
Mission (Luiseno)

Super Kachina, 1976
Acrylic, 80 x 68
Lent by Elaine Horwitch Galleries,
Scottsdale, Arizona

Three Indian Dancers, 1975
Oil, 80 x 68
Lent by Elaine Horwitch Galleries,
Scottsdale, Arizona

STONE, WILLARD, b. 1916
Cherokee

Exodus, 1973
Walnut, 36 x 36 x 12
Lent by The Cherokee Nation of
Oklahoma, Tahlequah, Oklahoma

Exodus II, 1981
Walnut, 12 x 18 x 12
Lent by the Artist, Locust Grove
Oklahoma

STROUD, VIRGINIA, b. 1949
Cherokee

*Old Flames—The Navajo Squaw
Dance,* 1980
Gouache, 29 x 22
Lent by Ni-Wo-Di-Hi Galleries,
Austin, Texas

Where From Here, 1980
Gouache, 29 x 22
Lent by Ni-Wo-Di-Hi Galleries,
Austin, Texas

TSINAHJINNIE, ANDREW, b. 1918
Navajo

Card Game, 1978-81
Tempera, 31 x 38½
Lent by The Kiva Gallery, Gallup,
New Mexico

Pastoral Scene, 1971
Tempera, 20½ x 32
Lent by The Kiva Gallery, Gallup,
New Mexico

WEST, W. RICHARD, b. 1912
Cheyenne

After the Sweat, 1981
Cedar, 24 x 5½ x 4½
Lent by the Artist, Fort Gibson,
Oklahoma
Now owned by Private Collection

Water Serpent, 1978
Oil, 34 x 30
Lent by the Artist, Fort Gibson,
Oklahoma

WHITE, RANDY LEE, b. 1951
Souix

Custer's Last Stand Revised, 1980
Mixed media, 72 x 96
Lent by Elaine Horwitch Galleries,
Santa Fe, New Mexico

Horse Dance, 1980
Mixed media, 31½ x 47½
Lent by Elaine Horwitch Galleries,
Santa Fe, New Mexico

WILSON, LYLE, b. 1955
Haisla/Kwakiutl

Crest Memorial of the Haisla, 1980
Pencil, 15½ x 22¼
Lent by Mr. and Mrs. Ray A.
Barnett, Point Richmond,
California

*The Shaman Restores a Dead Soul
to Life,* 1980
Pencil, 14 x 19½
Lent by Bent Box Gallery, Ltd.,
Vancouver, British Columbia,
Canada

INDEX

Namingha, Dan, 88, 100; *Eagle Dancer, 89; Mesa, 88*
Native American art, artistic evolution in, 7; bibliographies of, 7; categories of, 103; classification of, 4; conflicts in patronage of, 13; contemporary social commentary, 5; conventional themes, 5; critical assessment of, 7; current trends in, 109; distinction among media, 102; fundamental changes in, 3, 5; historic expressionist, 4; historical development of, 102; humor, 113; individualist, 4; modernist, 4; motifs in, 113; museum exhibition catalogues and gallery guides, 105; museums and galleries as showplaces of, 103; nature of, 101; philanthropists' effect upon, 11, 12, 13; pictorial overviews of various regions, 106; question of legitimate style of, 16; relationship to society. 107, 112; relationship to Southwestern culture, 102; relation to tribal life and legend, 112; regional and geographical styles of, 113; traditionalist, 4, 16
Native American Church, 56
Navajo pictorial rug, 116
Neocubism, 54
Niman Ceremony, 106
Northwest Coast materials, 114; themes, 30, 32, 34

Ojibwa-Cree-Odawa school, 91

Painting, Native American, emergence of styles in, 105; Native American descriptive essays, 105; plains, 109

Peyote school, 50
Peyotism, 56
Philbrook Art Center Indian Annual, 4, 12, 40, 57, 110
Photorealism, 70
Piki bread, 43
Penn, Robert, 14
Polelonema. Otis, 6; *Zuni Bean Dance, 6*
Pottery, pueblo, continuity and change in, 7
Primitivism, effects on modernism, 107

Quick-to-See-Smith, Jaune, 80; *Camas Series. Untitled, 81; Horse Constellation with Jack Rabbit, 80*
Quimby, George Irving 104
Quintana, Ben, *Deer Dancers, 4*

Realism, 92
Reductionism, 108
Reid, Bill, 4, 34: *Mythological Screen, 34*
Royal Canadian Society of Arts, 92

Sacred Circles, exhibition, 90
Santa Fe Indian Market, 12
Santa Fe School, 102
Santa Fe Studio, 4, 13; aesthetic policy of. 13; training at, 13
Santo Domingo pueblo, 10
Sapp, Allen, 6, 92; *Holding Her Baby, 93; Will Be Home Soon, 92*
Saul, Terry, *Choctaw Scalp Dance, 118*
Scholder, Fritz, 13, 14, 16, 58; *Super Kachina, 58; Three Indian Dancers, 59*
Shiprock, New Mexico, Indian Fair, 11
Shoshone elk hide, 113

Shupela, Douglas, *Pottery Makers, 10*
Sioux beadwork, 113
Southwestern Association on Indian Affairs, 12, 13
Southwestern Indian art, 114
Spirit world, 98
Stone, Willard, 49; *Exodus, 49*
Stroud, Virginia, 38, 41, 62; *Cherokee Curing, 107; Old Flames—The Navajo Squaw Dance, 41; Where from Here, 62*
Studio style painting, 109
Suina, Theodore, *Navajo Shepherdess, 13*
Sweezy, Carl, *Peyote Road Man, 115*

Tanner, Clara Lee, 66
Tents and rawhide carriers, 109
Tiger, Jerome, *Endless Trail, 111*
Tourists, anglo, 11, 12
Traders, involvement in Indian art market, 11
Traditionalism, 37
Trail of Tears, 49
Trickster, 95
Trompe l'oeil, 76
Trujillo, Dorothy, *Pueblo Potter with Umbrella on Market Day, 102*
Tsatoke, Monroe, 6
Tsinahjinnie, Andrew, 4, 45; *Card Game, 45; Pastoral Scene, 27, 44*

U.S. Indian Service, 11, 12

Velarde, Pablita, *Battle of the Serpents, 15; Keres Corn Dance, 5; Pottery Sellers, 10*

Warner, John Anson, 93
West, W. Richard, 4, 14, 52; *After the Sweat, 52; Water Serpent, 15, 57*
White, Randy Lee, 36, 67; *Custer's Last Stand Revised, 28, 36; Horse Dance, 67*
Wilson, Lyle, 4, 30; *Crest Memorial of the Haisla, 30; The Shaman Restores a Dead Soul to Life, 31*

ABOUT THE AUTHORS

Edwin L. Wade, Curator of Native American Art at Philbrook Art Center, is the author of many books and articles on American Indian culture, including *Historic Hopi Ceramics from the Thomas Keam Collection* (Harvard University), *America's Great Lost Expedition* (Heard Museum), *Pottery from the Thomas Keam Collection of Hopi Material Culture* (National Park Service), and others. His numerous research grants and awards include those from the National Science Foundation, the National Endowment for the Humanities, the School of American Research, and the Weatherhead Foundation. Dr. Wade holds a Ph.D. in anthropology from the University of Washington. Before assuming his current post in 1981, he held the position of assistant director and manager of collections at the Peabody Museum of Archeology and Ethnology, Harvard University.

Rennard Strickland is the John W. Shleppey Research Professor of Law and History at The University of Tulsa. Professor Strickland, a scholar of Osage and Cherokee heritage, has written extensively about American Indian life, law, and culture. Currently serving as Chair of the Philbrook Art Center Indian Committee, he has been involved for more than two decades in evaluating and collecting contemporary and historic Indian art. He is co-author, with Jack Gregory, of the American Indian Spirit Tales Series and editor-in chief of the revision of *Cohen's Handbook of Federal Indian Law*. In 1978 he received the Society of American Law Teachers (SALT) Award for "outstanding achievements . . . in the development and reform of legal, governmental, and societal institutions." Among his other books, also published by The University of Oklahoma Press, are *Fire and the Spirits, The Indians in Oklahoma,* and *Oklahoma Memories* (with Anne Hodges Morgan). Strickland received the J.D. and S.J.D. from the University of Virginia.

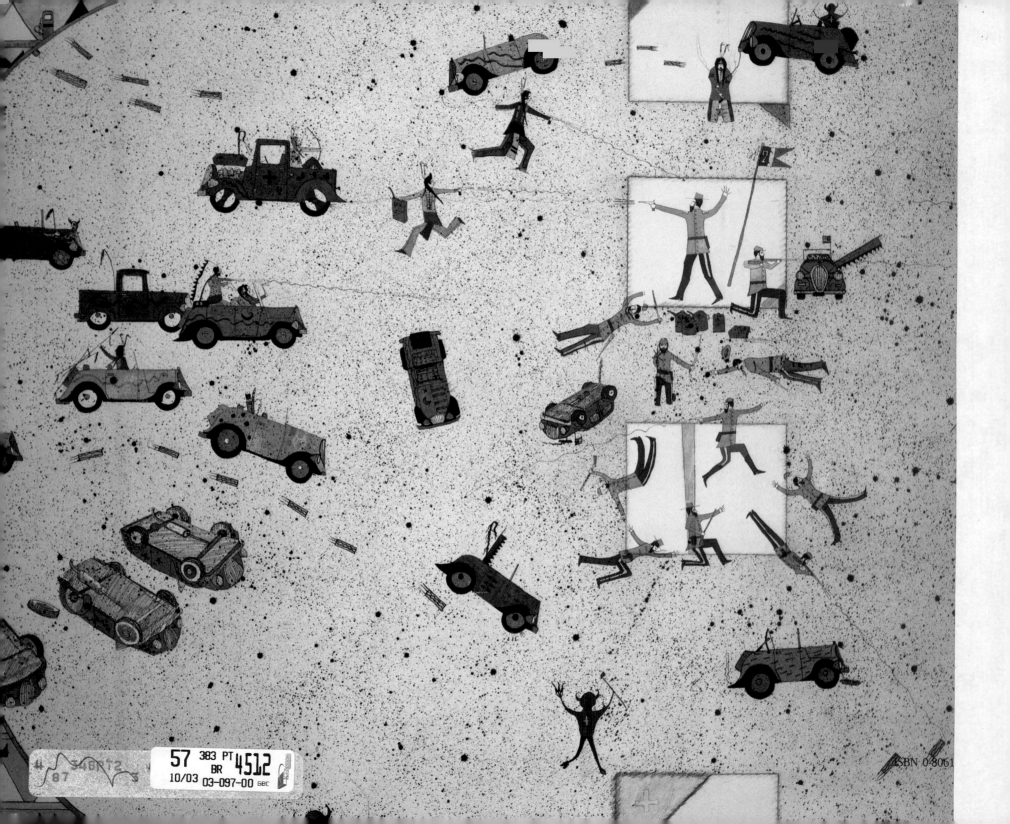

ISBN 0-8061